# A CULINARY HISTORY

## OF

# CAPE MAY

Salt Oysters, Beach Plums & Cabernet Franc

## JOHN HOWARD-FUSCO

AMERICAN PALATE

Published by American Palate
A Division of The History Press
Charleston, SC
www.historypress.net

Copyright © 2017 by John Howard-Fusco
All rights reserved

First published 2017

Manufactured in the United States

ISBN 9781626195899

Library of Congress Control Number: 2016937196

# Contents

# FOREWORD

From the earliest days of Cape May's long and illustrious history, food has been much more than a means of mere sustenance to the Cape's inhabitants. The Kechemeche tribe of the Leni-Lenape Indians was the first to discover that the land was especially fertile, while the surrounding seas were filled with a wide variety of potential delicacies.

They distributed their daily catches and harvests among the tribe just as readily as they traded what we now know as Cape May diamonds. Those water-worn pieces of quartz were thought to have mystic healing powers by the Indians, while the food was considered a blessing from the Great Spirit, meant to be shared.

Cape May's initial foray into the world of hospitality was rooted in those same fertile lands and seas, with each visitor being fed by his or her hosts. It was common practice for a room to come with board and for tavern owners to serve guests from their personal farms and fishing boats.

Much has changed over the centuries, and yet much has stayed so perfectly simple in a community that exemplifies the ideals of "farm to table." *A Culinary History of Cape May* tells the tale well and is a true pleasure to read. John explores the history of a subject we can all appreciate throughout this fine tome and shares more than a few stories that have been lost in time. To categorize this as merely a history book would be a gross understatement, akin to calling succulent, caramelized local sea scallops in a rich beurre blanc sauce "a seafood dish."

Enjoy the history and embrace the Cape May cuisine!

BEN MILLER,
Author of *The First Resort, In the Land of Exit Zero* and *Cape May Moments*

# ACKNOWLEDGEMENTS

While the actual writing of a book is a solitary affair, along the way the author gets the pleasure and privilege to meet and work with wonderful people who are just as excited (and sometimes even more so) about the subject matter.

Right out of the gate, a big thank-you goes to Lisa Marie and all the staff at the Cape May County Library in Cape May Court House for all of their help while I toiled away there for hours upon hours. And right up the street from the library, thanks are in order for Laurie Thomas in the archives department of the County Clerk's Office. We got that same sparkle of joy when coming across historical tidbits. Sonia Forry at the Cape May County Museum and Genealogical Library was a tremendous help in navigating the volumes and volumes of local history.

Finding great images for the book was a journey unto itself. Thankfully, I could share the journey with Richard Gibbs, Don Pocher, Bunky Wertman, Roy Baker and Liz Pongia. I cannot thank you folks enough!

When you need information about farming in an area, you need a Joe Alvarez. Joe is a fount of knowledge, not to mention pretty adept with the camera. The same could be said for Brian Harman of Atlantic Cape Fisheries, who bestowed a lot of knowledge on me about oysters.

Warren Bobrow could be woken up at three o'clock in the morning and still make a drop-dead wonderful cocktail. Fortunately for him, just a few recipes were requested for this book. Thank you, Warren.

# Acknowledgements

Mary Ockrymiek of Cape May Food Tours was a great help right from the start of the project, offering ideas and guidance. Pat King from Slow Food South Jersey Shore was spot on in guiding me to local experts.

When I needed something and in a hurry, Lisa Johnson and Phaedra Laird from Lisa Johnson Communications were right there and got things done like the ninjas they are.

Thanks go to those who shared their stories with me: John Cooke, Carol Boyd, Steven and Lenore Dash and Carrie (Dash) Warwick and Curtis Bashaw. And speaking of Curtis, thanks to all at Congress Hall who helped out.

Thanks also to all the people who work on the farms and in the restaurant and hospitality industries that were part of this project: Leslie and Diane Rea of Rea's Farm, Charles Taylor of No-Frills Farm, Elizabeth Degener of Enfin Farms, Chef Jeremy Einhorn of Congress Hall, Chef Lucas Manteca of the Red Store, Brooke Dodds of Empanada Mama's, Lucas Turdo of Tudro Winery, Dr. Bruce Morrison of Jessie Creek Winery, Todd Wuerker of Hawk Haven Winery, Kay Busch at the Mad Batter and Hilary Keever at Good Earth.

Thanks to Whitney, Stevie and Chad at The History Press for keeping me from jumping out of a window when I felt the urge.

A special thank-you goes to Ben Miller, who took the time to help me out with photos, with his experiences and his overall positive encouragement.

And last but not least, thank you to my wife and partner in crime, Lisa, who gave me the space to go crazy for periods of time putting this book together.

# INTRODUCTION

*We make specialties of sea breezes, salt-oysters, fat fish and ocean waves.*
—Cape May Ocean Wave, *June 3, 1875*

Cape May, "America's Oldest Seaside Resort," has many tales to tell. From the Native Americans who hunted, fished and grew crops to a whaling village settled by migrating colonists, the premier resort for the affluent in Philadelphia and other major eastern cities and today's mixture of old and new existing together, this queen of Jersey Shore towns has seen plenty of change. And food has been a part of these tales all along the way.

While the history of this famed seaside resort has been focused on the draw of the seashore and the hotels that would care for the needs of those who came to visit, behind those buildings was a community of farmers and fishermen that worked hard on land and at sea. Like a tree falling in the woods that may need a recipient to hear if it actually makes a sound, food needs to be eaten by living beings in order to be called food. The culinary story of Cape May, then, is about relationships. There is the relationship between humanity and nature and how humanity has used, abused at times and cared for the natural resources of land and sea and the creatures that have lived in those areas. There is the relationship between those who farmed and fished and those who prepared and served the meals, as well as with those who eventually ate those meals. At times, those connections were happy and joyful; at other times, they brought about conflict.

And there is also the relationship between two cities: Cape May and Philadelphia. More than two centuries in the making, Philadelphians still hold a fondness for Cape May. Joe Alvarez, who knows more than just about anyone about farming in Cape May County, told me that he came to West Cape May from South Philadelphia fifteen years ago and never left.

The modern farm-to-fork and slow food movements of the late twentieth and early twenty-first centuries have raised the conscience of the dining public, which began to ask, "Where does my food come from?" But for the most part, those who live in Cape May have always had a pretty good idea. The local residents have never been too far from a farm or the water. This relationship has always been present in the local restaurants, and as the food tale of Cape May unwinds in the pages to follow, my hope is that this relationship connects with you as well.

My love affair with Cape May did not start until my twenties, when my girlfriend (who would become my wife) and I started taking long car rides from North Jersey, down the Garden State Parkway, until the very end—"Exit 0," as it is affectionately known. We would stay at beautiful, cozy bed-and-breakfasts, enjoy wonderful dining experiences and shop along the Washington Street Mall. In later years, we would delve into the history of Cape May, appreciating the old, vibrant architecture as well as the beach—the kind of refreshing and life-affirming beach that only the Jersey Shore can provide!

This book begins with the first humans with whom we can find some connection: the branch of the great Lenape tribe known as the Kechemeche. From there, we see the movement of colonists from places farther north down to Cape Island to hunt whale and start a new life. Whaling would not stay here, but for the people who did stay, they were able to grow crops and livestock, gather clams and oysters and fish in the ocean and bay—enough to survive and trade with other parts of the colonies.

When sea bathing became a desirable exercise in the latter half of the eighteenth century, Cape May changed from a rugged destination to a great sea resort. Along the way, the meals available to travelers changed from rustic to refined as the well-to-do bathers from Philadelphia, Baltimore and New York and from the South required more than just a simple meal and a stiff drink. The influx of visitors also gave rise to the confectionery shops, where the first meetings of ice cream and sea breezes would take place.

Cape May would also see its setbacks. Fires in 1869 and 1878, as well as the fire that felled the great Mount Vernon Hotel in 1856, would forever change the look of the seaside resort. It would also see challengers to its

prominence from upstart shore towns—the biggest being the easternmost terminus of the new railroad line from Philadelphia to Absecon Island: Atlantic City. Cape May would find itself in a constant state of trying to redefine itself and explore new industries. Part of the reshaping would come from a new wave of immigrants, who would put their own stamp on the food that would be available to the summer visitors.

The Cape May of the twentieth century would be one of unfulfilled promises and slow decline. And yet the beginnings of what we now think of as Cape May were being solidified—those bars and eateries that made it through the wars and Prohibition. And those same places would be there when this grand old shore town eventually came to the conclusion that the way to survive and thrive was not by looking outward but rather by staying within, bringing out the best of what already existed: the sea, the grand buildings and the bounty of locally sourced food.

The majority of this book will focus on the food history of Cape Island, which includes Cape May, West Cape May and Cape May Point. There will also be the occasional excursion over the causeway into other parts of Cape May County, going as far as Cape May Court House. We will, however, stay away from other communities along the shore in Cape May County such as Stone Harbor and the Wildwoods, which have their own unique food histories.

In this book, I hope to shine some light on the farms and farmers, the fish and fishermen, the restaurants and cooks and all who have been a part of the rich culinary history of Cape May. These pages are not intended to be the be-all, end-all of discussion on this subject but rather the ice-breaker of conversation. I am sure that those who have enjoyed any or all of the culinary delights of Cape May have their own tales to tell.

# Chapter 1
# FROM THE LAND OF THE KECHEMECHES TO A RESORT FOR HEALTH

Cape May's journey from a land where Indians hunted and fished to the "Original Seaside Resort" would take a few centuries, but there were a few constants along the way that connected the two: the draw of the wild game, the abundance of fish and oysters in the Atlantic Ocean and Delaware Bay and the pull of the sea itself. These treasures have been, as they are to this day, the magnets that have pulled humans to this beautiful place.

## THE FIRST TO EAT IN CAPE MAY

When it comes to any discussion or written text about the food history of a particular place in the United States, it must begin with the original inhabitants. The first people who made it to the coast of what we know as New Jersey are believed to be the Paleo-Indians, who crossed over the land bridge from Asia to North America and would eventually make their way to what we now call the Atlantic Ocean about twelve thousand years ago (give or take a day or two). These inhabitants had the ability to use fire as well as create tools and weapons.

The animals that were hunted were used almost in their entirety. The meat was eaten either raw or roasted over fire. The rest of the animal would have been used to make tools, hunting weapons, necklaces, materials to build their shelters and clothing. Fossilized remains found around the Cape May

County area and under the Atlantic Ocean have shown that caribou, walrus and even mastodons roamed these lands and would have been sources of food and other items.[1]

For the culinary purposes of our story, however, the Paleo-Indians offer us very little. We will move the story of Cape May's food history forward several thousand years. The next group of native inhabitants that we know about, and the people whom the early European explorers and settlers encountered, were the Kechemeches of the Lenapehoking, homeland of the Lenapes.

## The Kechemeche Tribe of the Lenape Nation

A small subdivision of the Unami-speaking Lenape tribe,[2] the Kechemeches came to the Cape May region for the water, the fish and the wild game that was available and plentiful. It has been estimated that the size of this group was a mere fifty men, women and children. Whether the Kechemeches had established a more permanent village on the cape is not clear. There is evidence to support a more permanent village, such as shell piles and skeletal remains that were discovered in the early part of the twentieth century.[3] But there has yet to be discovered any evidence of horticultural activities such as the growing of crops.[4]

Whether the tribe stayed or kept moving, the men of the tribe were responsible for the hunting of birds and game, as well as collecting the oysters and clams and fishing the seas. Their primary hunting weapons on land were bow and arrow and spear. The area was plentiful with resources of wild game such as deer, raccoon and rabbit, as well as duck, geese and turkey. In the water, the men used harpoons as well as fence-like netting called a fish weir to catch fish.

The women of the tribe were responsible for the gathering of wild plants, berries and eggs, as well as the cooking. Strawberries and blueberries, along with wild plums, apples and acorns, were available in the region for gathering. Acorns and other kinds of nuts were used to produce oil for cooking. This was done by roasting the nuts in their shells and then pulverizing them. The next step was to place the nuts in boiling water; the oil floated to the surface of the water.[5]

Two meals were prepared each day, one in the morning and one in the evening. And there was usually a pot kept over the fire with a meal available

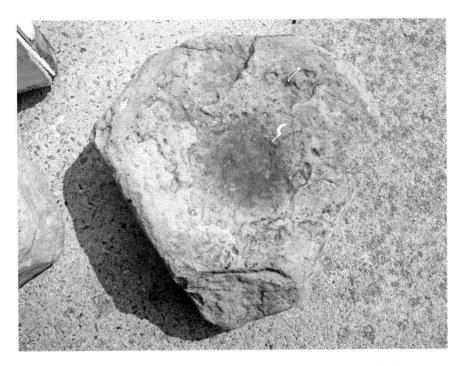

This large stone, found at Rea's Farm in West Cape May, is believed to be an Indian grinding stone, which would have been used for grinding corn.

for visitors. The Kechemeches did not eat meat that was raw or even rare. Their food was thoroughly cooked.[6]

The women were also responsible for drying and smoking meats and fish for preservation. Meats were jerked by being cut into strips and dried in the sun by a fire. The jerked meats were used in many different ways: boiled with vegetables or corn, added to soups and stews or grounded up and mixed with animal fat or bone marrow and formed into a cake that could be carried by hunters. The mixture of dried meats and wild berries is known by us today as pemmican, the energy bar of the Native Americans.

If crops had been planted, the responsibility of clearing space by burning and then removing the brush was handled by the men of the tribe. The women were charged with the planting and growing of the crops, as well as the grinding of corn to make meal for bread.

When the Europeans arrived, there would be trade and treaties between the two groups. But in the end, the Kechemeches moved on from this land. King Nummy, who became known as the "king" of the Kechemeches, left the tribe in 1735.

# The First Europeans Arrive

Henry Hudson was the first to sail around Cape May. In 1609, his ship the *Half Moon* made its way through the rough, unchartered waters where the ocean met the bay. But the cape is not named Cape Hudson. The name Cape May came from Cornelius Jacobsen Mey, a Dutchman who sailed around the cape on his ship *Blyde Boodschap* (*Good Tidings*) and declared the climate to be "like to that of Holland." Mey would become the first director-general of the New Netherlands in 1623.

Fellow countryman Pieter Heysen, a whaler by trade, bought a tract of land on the cape that ran four miles along the Delaware Bay and four miles inland. On the deed (dated June 3, 1631), the land was described as such: "the inland waters were found to abound in oysters, clams, crabs, and other shell fish."[7]

But it would not be the Dutch nor even the Swedish (who briefly had their colonization period from the 1630s to the 1650s) who would colonize Cape May. It would be the English, who took control of the land now known as New Jersey in 1664. Cape May was considered part of West Jersey, which had its center of government in Burlington along the Delaware River. Cape May was a long ways away from Burlington and was seen as remote and isolated.

# Dr. Daniel Coxe and His Ambitious Plans

Dr. Daniel Coxe was an English doctor, a court physician for King Charles II and a member of the Royal Society. He was also quite interested in landownership in the New World and in establishing a whaling fishery. By 1687, Coxe had acquired ninety-five thousand acres of land in present-day Cape May County and believed that a whale fishery there would be able to produce £4,000 per year,[8] which would have been a tidy sum indeed.

A whaling community of some sort had already been established in the area that Coxe had purchased. Along the bay side of the cape, a settlement known as Town Bank (also called New England Town after the location where these inhabitants had migrated from) arose around 1687. Coxe got these whalers involved in his plans and encouraged additional whaling families to come and settle there.[9]

But Dr. Coxe's ideas did not stop there. He saw the wide variety of fish available in Delaware Bay, not to mention the timber in the region, as an

opportunity to establish trade with the West Indies, as well as with Portugal and Spain. Dr. Coxe also believed that the wild grapes growing in the area could be harvested and made into fine wine. He sent French Huguenots from Long Island to help establish his whale fishery, as well as to harvest salt, cultivate the wild grapes and grow fruit trees.

But very few of these schemes came to fruition. Even his belief in the whale fishery would become tempered. Four years after pronouncing that his whaling enterprise would generate £4,000 per year, Dr. Coxe revised his outlook down to £500 per year.[10] Although Dr. Coxe considered relocating to America, he never stepped foot in the New World and eventually sold all of his holdings in Cape May in 1692 to a group of London businessmen called the West Jersey Society.

Looking to make its new holdings profitable, the West Jersey Society attempted to follow through on some of Dr. Coxe's ideas. It sent one of its agents, Nathaniel Westland, to Cape May to work on developing the fishing and wine industries. Sailing on the *Jersey Ketch*, Westland was instructed to make wine and brandy and send back "a sample at ye first opportunity."[11] But these plans, as well as having fishermen from Bermuda immigrate to West Jersey, did not amount to much success.

## WHALERS AND YEOMAN FARMERS

The first settlers to what became known as the Cape came from Massachusetts Bay, Connecticut and Long Island. While the more tolerant religious environment was certainly an enticement, it was the potentially lucrative trade of whaling that was the main driving engine. Additional attraction to the region was also inflamed by Thomas Budd, who published a pamphlet about the region's good farmland and maritime opportunities.[12]

Whaling may have brought people to Cape May, but it was farming and fishing that sustained them. Unlike the original settlers to places such as Jamestown and Plymouth Rock, who had to learn how to cultivate these new foreign lands, these were people who brought their existing knowledge of farming and could put that to use.

The early landowners in Cape May, regardless of their occupation, farmed their land. This is a yeoman concept that was brought over from England. Typical crops that these early settlers would have grown included Indian corn, wheat and rye. They raised livestock, including horses, pigs,

oxen, cattle and sheep. They also possessed beehives for honey and to help pollinate their land.

Farming in the Cape May area posed its own set of challenges. First of all, the area that could be farmed in this county was significantly less than what could be found farther inland. In addition, the sandier soil was not as fertile as the marl-rich soil found inland.

The General Assembly of the Province of West Jersey officially established the county of Cape May in 1692, and the first county court of record took place in March 1693. It is interesting to note that during the proceedings, one of the orders of business was to take care of the grand jury's collective stomachs: "A rule of court passed the grand jury shall have their dinner allowed them at the county charge."

By 1699, there were seventy freeholders in Cape May County, and some of the names would become significant in the food history of Cape May, as well as the overall history of the area. Those names include Thomas Leaming, Jacob Spicer, Cornelius Schellenger and Humphrey Hughes.

The daily living within the houses of these early inhabitants centered on the fireplace. It was where meals were cooked, and it was also located in the room where the adults would sleep. Some houses would have built a separate kitchen house, while others would build an addition, or "lean-to," on the side or back of the house that was used as a kitchen for meal preparation.

Besides the landowner and his family, who else worked the land? Many of the yeoman farmers were not farmers by trade and had their main occupations to which to attend. One source of labor was supplied by Indians. While the local Native American tribes had left the area, some stayed behind and worked for these landowners. An article in the *New-York Weekly Journal* in 1736 reported of a quarrel gone terribly wrong between Joseph Golden and three Native Americans hired by Golden to work on his land. Paying the laborers with three quarts of rum, they, in turn, became drunk and argumentative. Serving alcohol to Native Americans in taverns was illegal at that time, due to issues with drunkenness. The quarrel became violent, and eventually Golden struck one of his workers with a lethal blow to the head.[13]

While writing in his diary in 1761, Aaron Leaming Jr. jotted down the following two entries:[14]

> *May 31—"I set out from home to go to Philada. to buy a negro or two."*
> *June 5—"I carried the negro boy I bot down to Gloucester…and gave Mr. John Robinson an order to receive him and carry him to Cape May."*

To the modern sensibilities, these words come across as cold and cruel, too matter-of-fact and businesslike for the "transaction" that was taking place. But that's a twenty-first-century perspective on what was then a common occurrence, even in the colony of New Jersey. Although Cape May County did not have the large farms and plantations that existed farther south, a number of the yeoman farmers of this period felt it necessary to purchase slave labor to help with their cultivation. Slave ownership in Cape May goes back as early as 1688, when two of the landowners in the county owned five slaves. That number would increase to fifty by the middle of the eighteenth century.[15] When the first census of the United States was taken in 1790, the population of Cape May County was 2,571, of which there were 141 slaves and 14 free African Americans.

By the latter half of the eighteenth century, whaling had ceased to be a sustainable industry in the area. The original Town Bank whaling settlement had completely eroded into the Delaware Bay by 1724. The industry had moved on to more profitable locations, such as Nantucket in the north and the Carolinas to the south. The fact that whaling continued to be a major industry in the United States well into the nineteenth century, but not in Cape May, demonstrates that it was not sustainable there. But the community had already moved on, having been able to sustain itself through farming, fishing and trade.

## Cape May as a Regional Port

Because of its location, it would make sense to think that Cape May would become a busy port for trade. And it was, regionally. Cape May was not an official port of entry, such as Philadelphia, Boston, Burlington, Salem and Perth Amboy. It was more of a regional port, where its goods were going either to the colonies to the north, to Philadelphia and Burlington or to other smaller ports along New Jersey. Shipments to and from the West Indies also found their way to Cape May, even though it was not a port of entry.

Jacob Spicer, the son of the Jacob Spicer who came to Cape May in 1695, was a merchant who was heavily involved in the shipping of goods. With his small shipping vessels, Spicer would personally make trips from Rhode Island to North Carolina. Corn, wheat and other foodstuffs, as well as timber, would be sent to Philadelphia and New York. He was a shrewd

businessman, requiring cash upon receipt of any consumable luxury items, including wine, rum, sugar, molasses, tea, coffee and chocolate.[16]

It is the destinations of Philadelphia and Burlington that are of most importance to the culinary story of Cape May. The produce grown and the oysters collected were shipped to these areas, first by boat and then later by wagon, once the causeway was built in 1699 and the first road in 1707 connected the county with the rest of West Jersey.

## Early Taverns in Cape May

Dining out in colonial America was mostly done by those who had to travel. The system of establishing taverns as a means to help facilitate traveling was first introduced to the New Jersey colony along the Passaic River in Newark in 1666. It is here where the first tavern—or ordinary, as it was called—was opened for business.

Being a county that was considered backwater, the number of taverns and public houses that existed in Cape May County was, at first, small in number. Although the distinction of being the first licensed tavern owner in Cape May County goes to Jacob Ludlam Jr. in 1740, the first tavern keeper in the area may have been several years earlier. Records of a town meeting on May 10, 1692, that took place at the house of Benjamin Godfrey would suggest that his dwelling was the first house of entertainment in the county.[17]

As the building of roads increased in the latter half of the eighteenth century, the need for taverns increased. Some of the more well-known taverns of this period were run by Abraham Bennett or by a pair of brothers, Memucan and Ellis Hughes. The significance of Ellis Hughes becoming a tavern owner will become apparent shortly.

As with any tavern of this period, the primary purpose was to provide sustenance and a place to sleep for travelers. What was served to you as food was whatever they had available for that day. The quality of your meal could vary…greatly. And then there was alcohol, which provided the real reason as to why people came to taverns. At least you had a better chance of knowing what you were getting, be it Madeira wine or rum from the West Indies.

The alcohol would help grease the wheels for the other important purpose of taverns: a place for people to gather together to discuss the events of the day. Whether it was local gossip or the bigger political powderkegs, taverns were essential for the exchange of information and ideas.

In order to obtain a license, a fee had to be paid. In Cape May County, the fee for a tavern license was about ten to twelve dollars. In addition, a potential tavern owner would be vouched for by others to establish that this person was of good character and moral standing. There was no equivalent of a board of health at that time, so maintaining a clean tavern was not part of the equation.

## Cape Island During the American Revolution

During the war, when local farmers from Cape May went to fight, they had to leave their families and farms behind them. It was up to their spouses to maintain their farms. This would include not only the raising and harvesting of crops but also such tasks as the slaughtering of chickens and pigs. There were no markets from which to obtain these items in Cape May at this time, so individual families had to be self-sufficient.

The big industry in Cape May during the war was privateering. With the approval of the young American government, and working with the merchant houses in Philadelphia, locals commandeered such items as sugar, molasses and coffee. In essence, these individuals were literally given a license to steal by the Continental Congress. Thomas Leaming Jr. was very successful at privateering, having captured fifty prizes (including a vessel carrying Hessian troops).[18] But the relationship between Cape May and Philadelphia businessmen would be the beginning of a strong economic connection between these two locations, and it is a connection that can still be seen and felt to this day.

## Bill of Fare:
## Cape May County Tavern Rates for 1801

Throughout this book, we will be taking a look at sample menus (or bills of fare, as they would have been referred to for most of the nineteenth century) for what diners would have available to them in Cape May at certain points throughout its history. The purpose is to show how what was eaten and the styles in which food was served changed over the years.

In the young republic of the United States in 1801, the ordinary- or tavern-style of meal was what was available to those who traveled. In Cape

May County, the rates that could be charged by licensed tavern owners were set by the Court of General Quarter Sessions of the Peace. The initial list of established rates was inscribed in the records on May 28, 1801:[19]

*Breakfast—25 cents*
*Dinner—36½*
*Supper—25*
*Night's Lodging—7*
*One gill of West India Rum—10*
*Nip of Mint or Toddy—12½*
*Bowl of Toddy—25*
*Bowl of Punch—40*
*Bowl of Egg Punch—33*
*Sling of Egg Punch—16½*
*Pinte of Madeira Wine—50*
*Pinte of Teneriffe Wine—33*
*Bowl of Sangaree—25*
*Bowl of Brandy Toddy—26½*
*Mug of Strong Beer—12½*
*Mug of Cider—7*

The first question that probably comes to mind is, "Where's lunch?" Well, at this time, lunch (luncheon) was more of a light snack that ladies might have enjoyed in the middle of the day. Dinner was the big midday meal, usually served sometime between 1:00 p.m. and 3:00 p.m. Supper was a smaller meal in the evening. The pricing of the meals listed here gives a clear indication as to which one was the most important.

The other immediate observation that can be made is that there is no description of what comes with each meal. In the days of the tavern, what was served at each meal was whatever the innkeeper had available. Local governments were only concerned with the pricing of meals at taverns. As for the quality of the meals, well, that was another story. This was the early nineteenth-century version of dining *omakase*, which in Japanese means to put your life in the hands of whoever was cooking. In this case, putting your life in the hands of the innkeeper was not necessarily a good thing. The quality of food served varied greatly.

The more detailed descriptions in the rate list were reserved for the alcoholic drinks. The wines of Tenerife (from the Canary Islands, which were held by Spain) and Madeira (from the Madeira Islands, held by Portugal) were quite

commonplace. These were fortified wines that were able to withstand the long sea voyages to America. Rum from the West Indies was also a tavern staple.

This list of drinks also shows the beginnings of mixed drinks or cocktails. A sangaree consisted of a fortified wine (port, sherry, Madeira), water, sugar and nutmeg. A toddy was hard liquor (rum, whiskey, brandy) mixed with sugar and served either warm or cold. A sling of egg punch was like eggnog that was heavy on alcohol.

As for the size of each drink, the waters get a bit murky. A gill was roughly four ounces (or about a quarter of a pint). A nip (short for nipperkin) has been described as being anywhere from a half of a pint to a thirty-second of a pint, but it probably was more like an eighth of a pint. And as for the size of a mug or bowl, there is no real consensus.

# END STORY: ELLIS HUGHES PLACES AN AD

In 1766, Robert Parsons placed an advertisement in the *Pennsylvania Gazette* about his house for sale. In the description, he told the reader that the house is "within One Mile and a Half of the Sea Shore, where a Number resort for Health, and bathing in the Water; and this place would be very convenient for taking in such People."[20] Sea bathing had become an activity to engage in for health reasons, thanks in part to King Charles II, who did so himself. But here was an ad that was saying, in essence, if you buy this house, you may be sitting on a gold mine.

But it was the advertisement placed by Ellis Hughes in the *Philadelphia Gazette* in 1801 that came to symbolize the beginning of the summer holiday trade for this community. "Sea Shore Entertainment," the advert blared out, and then Mr. Hughes went on inform the public that "fish, oysters, crabs, and good liquors" will be available to his establishment.[21] There are a few notable things about this advertisement. Most prominent is the heading itself, which declared to the great city of Philadelphia that Cape May was open for business as a summer destination. A love affair between the two began—one that has maintained itself for more than two centuries.

But the listing of the food and drink items available is also a key element. Those who traveled to Mr. Hughes's house would have the opportunity to not only enjoy the sea but also taste the bounty harvested from it. Entertainment for all the senses to enjoy! This was the beginning of Cape May's life as a resort.

# Chapter 2
# A Table for All the Various Grades, Avocations and Professions

In the first half of the nineteenth century, Cape May transformed from an outpost of farmers and fishermen, where a few came to brave the surf, to one of the grandest and most highly regarded resort towns in the young American nation. Large houses, and later on hotels, would sprout up all along the shore to host the growing throngs of visitors. The menus would change dramatically over this period, as the level of sophistication of both the hotel owners and their clientele changed. In order to supply the growing demands, the local farmers and fishermen, who were still present and going about their business, would have to meet the challenges of feeding the guests of the city as well as providing the transportation from steamships to the large houses.

## The Hughes Family:
## Cape May's First Family of Accommodation

When Humphrey Hughes purchased land from Dr. Daniel Coxe in 1689 and migrated down from Long Island, he could not have imagined what his descendants would make of the land on which he let his cattle graze. The future of Cape May as a summer resort would be directly shaped by his descendants.

Two of his great-grandchildren, Memucan Hughes and Ellis Hughes, would become licensed tavern keepers. Memucan had a license to keep a

tavern during the years 1768–71, 1774–76, 1789 and 1792. He also got himself into trouble with the local authorities in 1799 by being indicted by a grand jury for causing a public disturbance.[1] Ellis Hughes, the one who placed that famous advert mentioned in the last chapter, had built his Atlantic Hall in 1800. His most famous visitor was Commodore Stephen Decatur, who was known to be skilled at making chowder.[2] Ellis would be the tavern keeper of his Atlantic Hall until his death in 1817.

Yet it was Ellis's son, Thomas H. Hughes, who built the house that completely altered the future of this seaside community. Thomas's house was opened in 1816 to the ridicule and jesting of the locals. "Tommy's Folly," they called it. The Big House by the Sea, as it was more respectfully referred to, was indeed much larger than the inns and taverns that had existed. The building was three stories high and more than one hundred feet long. The first floor had a large dining room area. At the time it opened, the Big House was arguably one of the largest hotels in the world.

But Hughes would be right in his thinking, and his house would be a success. When the Big House was destroyed by fire in 1818, Hughes built an even bigger house to hold even more guests. To keep up with the demands of his hungry patrons, Hughes's hotel depended on shipments by boat and stagecoach for items such as butter. His Philadelphia guests would settle for nothing less than good hard Philadelphia butter. But as for the main dishes, the hotel relied on the fowl, seafood and other game that could be caught locally. It was said that a piece of beefsteak was not brought into Hughes's hotel from the beginning of summer until the end.[3]

Even with the success of his hotel, Thomas Hughes had even bigger aspirations. He ran for public office and was elected to the United States House of Representatives. In honor of his election, Hughes's hotel was renamed, and the moniker stuck to this day: Congress Hall.

## Bill of Fare:
## Cape May County Tavern Rates for 1825

In 1825, after maintaining the status quo for the cost of meal and a drink at a tavern for nearly a quarter of a century, the Court of Quarter Sessions updated the rates to the following:[4]

*The best Dinner or Supper, with a pint of good Beer or Cider—37½ cents*
*Second best or family ditto, with ditto—25*
*Best Breakfast of tea, coffee, or chocolate, with loaf sugar—25*
*Ditto of cold meat, with a pint of good beer or Cider—15*
*Good Madeira wine per pint—50*
*Other good foreign ditto per ditto—25*
*Fruit punch of good Spirits and Loaf Sugar per bowl—37½*
*Mim of good Spirits and loaf sugar per quart—25*
*Mull'd Cider per ditto—12½*
*Egg of Other Sling, with a gill of W. India rum and Loaf Sugar—12½*
*West India rum per half pint—15*
*Ditto per gill—10*
*Cherry ditto per ditto—10*
*Gin or brandy per ditto—10*
*Cider royal per pint—12½*
*Metheglin per ditto—12½*
*Good double beer per quart—12½*
*Good Cider per ditto—6¼*

The new rates provided a little bit more flexibility in the dining options, including some cold meat and a beer or cider for those traveling on the cheap. The cherry drink in question could have possibly been a cherry bounce, a mixed drink of rum and cherry juice.[5] Sugar was still not available in granulated form, so drinks were sweetened using loaf sugar, or sugar packed in the shape of a loaf or a cone. Cider royal could have been a half and half mix with cider and brandy or mead.[6] Gin, that juniper-infused alcohol born in Holland and madly popular in England in the eighteenth century, made the list in Cape May by 1825. And metheglin was simply mead with herbs and spices added.

# A RUGGED, BEAUTIFUL VACATION SPOT

For those who decided to make their way to Cape May in the 1820s for the waves, the fishing, the game hunting or maybe all of them together, it was not the most relaxing trip. From Philadelphia, where trips to Cape May by steamboat had been running since 1815, it was a good seven- to eight-hour excursion to arrive on the Delaware Bay side of the Cape.

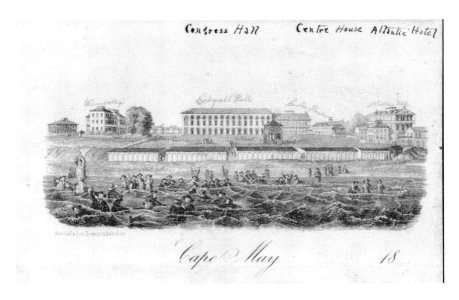

Artist rendering of the frolicking sea bathers (and their hats) at Cape May, with the ever-growing hotels in the background: Congress Hall, Centre House and Atlantic Hotel. *Congress Hall.*

Coming off the ship at the dock, passengers and their baggage were put on a farmer's Jersey wagon, which was built for utility and not necessarily for comfort. Now in tow, the visitors would make the four-mile journey from the landing area to the big houses of Cape Island. As they did, they would travel past acres of farmland where the fruits of the season would have filled the vista.

Upon arrival into Cape Island, the hope for every visitor was that the large houses would have enough rooms to hold everyone—many times they did not. Those without rooms would have to find lodging for the night at a smaller cottage or even a local farm.

In recent years, the activity of foraging, the gathering of wild edible plants, has become a trendy activity for gastrophiles. And while we in the twenty-first century try to get back in touch with where our food comes from, a person coming to Cape May could really get intimate with their meals back in the 1820s. One such visitor described how dinner was brought together one evening at the Atlantic Hall in 1829. The owner, Alexander MacKenzie, sent out someone to see if any of the neighbors had a sheep to sell. When one such specimen was found and purchased, all available men (including the diners themselves) helped with the dressing (preparation) of the mutton. Meanwhile, others were sent out to pick up some Indian corn from local

farmers to complete the meal. "When the mutton was cooked and the corn boiled," the visitor continued, "an appetite would have accumulated sufficient to make these viands seem like the ambrosia of Olympus."[7] We may not be ready for such intimacy in this age, but this example illustrates how far we have been removed from our food, and it also gives an interesting picture of the ruggedness that existed at the time on the Cape—a day at the seaside, followed by an evening of slaughter-your-own-meal at the boardinghouse.

## Culinary Change in the 1830s

*We have good fish, occasionally a sheepshead, lobsters, oysters but very small ones, poor beef sometimes, and the usual variety of fowls.*
*—a visitor to Atlantic Hall in 1829*

As Cape Island progressed into the 1830s, and the crowds of sea bathers grew exponentially with each summer season, the hotels stepped up their efforts to distinguish themselves. New hotels were constructed, each more refined and accommodating to the well-to-do who could afford such excursions. The crowds coming to the hotels were also becoming more sophisticated and particular. Expectations were growing, and the hotels would have to deliver.

In 1832, Richard Ludlam had built a new hotel called Mansion House, and it quickly became the standard by which others were measured. A visitor to Cape Island in 1833 remarked that the table at Mansion House was of the very best description.[8] Another aspect of the hotel that set it apart was that the walls were plastered—a departure from the unfinished, barn-like structures of the other large houses.

Plastered walls or not, the dining tables at each hotel became an increasingly important aspect of their business. It was not sufficient enough to sing the praises of the local fish and produce along with the best of what the Philadelphia markets offered—now the cooks preparing the meals began to serve a more prominent role.

An advertisement by the Atlantic Hotel in 1837 extolled the culinary traits of the new head of its culinary department, a Monsieur Porrot, calling him the best *cuisinier* in the country.[9] The Mansion House advertised in 1839 that good cooks and competent attendants had been hired for that summer's season. This was a far cry from the previous decade, when visitors had to help out the hotel staff with the dressing of the evening's main course.

## Cocktails by the Seaside

The whimsical, playful scenes that have survived from the nineteenth century portray this notion of a childlike innocence that existed during the summer seasons. But make no mistake: there was also a lot of drinking going on in Cape May. Some of it had to do with the water supply, which was known to be of questionable nature in Cape May. But America was a drinking nation, and those who were able to travel to seaside resorts such as Cape May were more than happy to imbibe.

During the 1846 summer season, one visitor remarked that the hotel they were staying in had "the constant perfume arising from mint juleps and tobacco smoke."[10] By this time, the mint julep had become the mixed drink of choice for Americans. But other drinks with colorful names had become bar standards, such as the sherry cobbler and the brandy smash. And it was not just the men who were enjoying a cocktail or two. The ladies were also known to enjoy a cobbler or smash themselves after an invigorating frolic in the ocean waves.

## Recipes: Sherry Cobbler and Mint Julep

*Warren Bobrow, aka "the Cocktail Whisperer," is truly an expert when it comes to cocktails of the nineteenth century. He was gracious enough to provide for this book two wonderful variations on popular mixed drinks of this period. When fruit was at its peak, a few short moments of juicy glory after a sizzling summer, cobblers were crafted from the bounty of the harvests. But after a few days without electricity to cool the just picked and quite fragile fruits, they would rot quite quickly.*

### *Roasted Fruit Cobbler*

*Ingredients*

*crushed ice*

*2 ounces applejack*

*3 ounces Oloroso Sherry*

*2–3 shakes Peychaud's Bitters*

*2–3 drops Angostura Bitters*

*1 cup assorted fruits of your choice, berries, stone fruits, citrus fruits and so on (roast the fruits for 25 minutes at 400 degrees and then let cool)*

*Directions*

*Fill a cobbler shaker half with ice. Add all the ingredients (except for a 1/3 cup of the roasted fruits). Shake darned hard for 1 minute to pulverize the roasted fruits into the applejack and the sherry. Add some crushed ice to a wine goblet (a large burgundy glass will do). Strain the cobbler over the ice. Garnish with a further helping (2–3 tablespoons) of the roasted fruits over the top. Dot with both the Peychaud's Bitters and the Angostura Bitters to finish and serve. (The bitters are for good digestion.)*

## "Pearl Fishing" Julep

*This is a very New Jersey take on the classic mint julep using roasted peaches and freshly plucked mint along with high-quality New Jersey distilled rum and the historic spirit made from apples known as applejack.*

*Ingredients*

*2 ounces New Jersey Rum*

*1 ounce applejack*

*1 cup (approximately) roasted peaches (you'll need about two tablespoons per drink)*

*1 teaspoon, raw sugar*

*sprigs of fresh mint, as refreshing as a cool breeze in summer*

*ice, sparkling like jewels and dry as the desert sun, crushed in a Lewis bag*

*Directions*

*Gently muddle the mint with the raw sugar in a sterling silver Julep cup (don't muddle too much, lest the drink taste green). Add a tablespoon or more of the roasted peaches. Add a splash of the NJ Rum and the applejack. Add some ice and stir a bit more. Add more rum and applejack. Add more crushed ice—the silver cup should be quite frosty by now. Add more rum and then applejack to finish....Dive for pearls!*

# Ice Cream and Confections at the Shore

The serving of ice cream at the shore was helped along by the relationship between Philadelphia and Cape May. Philadelphians loved their ice cream and were proud of their all-milk no-egg brand of the frozen treat. The

pleasure gardens and confectionery stores that served ice cream had become common fare for those living in the cities of the Northeast, and it made sense that those same people would want ice cream as they sought the surf and salt air at the Cape.

In August 1837, a ball was held at the Mansion House, one of the many balls and hops thrown during the summer season on Cape Island. At this particular ball, the confections were the responsibility of Parkinson from Philadelphia. This would have been George Parkinson, who along with his wife, Eleanor, had been operating one of the more successful confectionery shops in Philadelphia.

By the early 1840s, enterprising Philadelphians such as Ayers W. Tompkins and Robert G. Simpson, who had their own confectionery shops in the city, had opened locations on Cape Island as well. Simpson advertised in August 1843 about his establishments in Cape Island, Cold Springs and on Queen Street in Philadelphia, one of the earliest mentions of an establishment selling ice cream on the Cape.

Confectionery shops would continue to pop up all over the Cape. Sarah Little served ice cream from her shop located right at the landing point where visitors met the waiting wagons. George W. Smith and his People's Ice Cream Saloon was a popular establishment during the 1860s and 1870s. Like many of his other fellow confectioners, Smith got his ice cream from Bruna's in Salem County (which had developed a reputation as a top-notch brand of ice cream in the region). John P. Bruna himself came to Cape May every spring to visit the business he supplied.

These confectioners also supplied candy from popular producers. Long before the Whitman Sampler became a part of the fabric of American culture, Stephen F. Whitman was a successful confectioner from Philadelphia and supplied many of the Cape May confectionery shops with his chocolate.

By the 1870s, there was no limit to the number of shops supplying ice cream. John Akin had his ice cream saloon on Washington Street and was a fixture for many years. Alice Weldon had

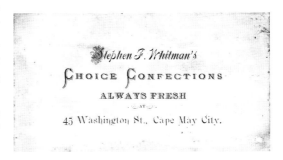

Business card of Philadelphia confectioner Stephen F. Whitman, who would become a staple of Cape May's confectioneries in the latter half of the nineteenth century with his chocolates. *Don Pocher.*

ICE CREAM! ICE CREAM! ICE CREAM!

Mrs. A. E. Barnes, No. 85 Washington Street, Cape May City, has the pleasure of informing her numerous friends that she will re-open her

# ICE CREAM SALOON,

for the season on

# Thursday Even'g, April 30.

All lovers of fine

## SALEM COUNTY ICE CREAM,

are invited to give her a call.

a23-2t.                              MRS. A. E. BARNES.

Advertisement for Mrs. A.E. Barnes's ice cream saloon in the *Cape May Ocean Wave* in 1874. At the time, ice cream from Salem County, New Jersey, was highly regarded.

her shop on Stockton Place and was known for attracting the highest of Cape May society. Dexter & Company at the foot of Perry Street mainly catered to a Philadelphia clientele. And then there was Mrs. A.E. Barnes and her ice cream garden. Hers was the only one of its kind in Cape May—a true pleasure garden in the style of those found in the major metropolitan areas in the northeastern United States.

One of the more intriguing figures in ice cream lore is Augustus Jackson, an African American man from Philadelphia who had at one time been a cook at the White House. One of the great myths about Jackson was that he had invented ice cream. This, of course, is completely false, as ices had been enjoyed in Europe long before Jackson was even born.

What we do know for sure is this: after returning to his hometown in the late 1820s, Jackson set up his own confectionery store and sold ice cream. He developed new methods of storage. He was not only able to sell his ice cream in his own shop, but he also sold his product to other shops. Jackson was so successful that by the mid-nineteenth century he had become one of the wealthiest African Americans in Philadelphia.

So, where is the connection between Augustus Jackson and Cape May? From a visitor to the Cape in 1844 came this observance:[11]

*And in the midst of the fun, our ears would be startled by the celebrated colored Philadelphia Ice Creamer who would suddenly appear in our midst and shout in stentorian tones, "Thraw-r-r-r-er-er-er-ra-rah-raw-ra: de lemmon ice cream…and de vannellar too-o!" This was part of our daily entertainment and the colored gentleman had many aspiring imitators. Someone asked him if he was not afraid he would injure his lungs but he said they had stood the service of seventeen years in the same line and he thought them proof.*

The number of years fits the time frame that Jackson had been selling his ice cream in Philadelphia. Could the "celebrated colored Philadelphia Ice Creamer" have been, in fact, Augustus Jackson? Frustratingly, there is no conclusive evidence that removes the shadow of doubt. Once again, Augustus Jackson eludes our grasp.

# NOT EVERYONE WAS CIVIL AT THE SEASIDE

Bringing together people from all over the eastern seaboard to a relatively small location in the hot summer sun did not always bring out the best in people. This was especially true when they all gathered together at the long dining tables of the Cape May hotels. The bringing together of many affluent (and some not so much) people made for an interesting mixture of conversation and interaction. These interactions included the levels of manners that were displayed toward the servers and to other diners.

On occasion, there would be altercations between diners. One man grabs a seat that another believed to be his, and the next you know the first man is being dragged from his chair. A visitor to the Mansion House in 1841 wrote about an incident between a young man who had joined the meal halfway through. After much motioning to the waiters for service, he finally was served some beef and a few potatoes. Upon seeing a woman next to him with an empty plate, he politely offered her some from his plate. The woman promptly scooped up his entire plate. The writer concluded by saying, "It is the gentleman's first visit. The lady has spent several summers here and understands the game of grab most perfectly."[12]

Not everyone was satisfied with the handsome tables that the hotels in Cape May were providing. Some of the accounts from visitors sound like they could have been posting these on a modern-day message board. Here's a rather stinging review by the same visitor to the Mansion House:

*The fish are good and tolerably well cooked but many of the vegetables are not only of very inferior quality but alarmingly scarce at that. Much of the cooking is bad, both overdone and underdone, and the dishing worse than the cooking, and all is aggravated by a scarcity of waiters.*

But tell us what you *really* think, my good sir.

## WHEN HENRY CLAY CAME TO TOWN

In the summer of 1847, Henry Clay came to stay for several days at Cape May. The senator from Tennessee, who was a national figure in the days when only newspapers connected the various parts of the country, was taking some time away from Washington. Senator Clay was still in mourning for the

**CAPE MAY.—CITIZENS' UNION LINE.**
*Fare through from Baltimore, only $2.50.*
Passengers for this celebrated "Watering Place" by taking the steamer GEO. WASHINGTON, Capt. Trippe, from Baltimore, on Mondays, Wednesdays and Fridays at 3 o'clock, P. M., will be assured of a passage to Cape May the next morning, by the superb, commodious and safe steamboat OHIO, Capt. Davis, which leaves Philadelphia on Tuesdays, Wednesdays and Saturdays, touching at New Castle for the Baltimore passengers.
☞Fare from Baltimore to Cape May, including hack hire at Cape Island, $2 50 only; meals extra.
jy4                  A. CRAWFORD, Agent.

Advertisement for excursions to Cape May from Baltimore for the 1846 season. Passengers from Baltimore would have to meet the steamboats at New Castle, Delaware, to make the journey. *Library of Congress.*

recent loss of his son and was looking for some restful time by the sea. He came to stay at Richard Ludlam's Mansion House, which at the time was considered one of the best of the Cape May hotels. Here the senator would have been able to feast on "fish, oysters, peaches, melons, and other luxuries, in profusion," as one correspondent reported.[13] In addition to taking in the sea air and the exhilarating ocean waves, Clay was also scheduled to dine at the Columbia House.

The extended stay of such a national figure showed that Cape May had become a major attraction during the two-month summer seasons. In addition, it was attracting the elite class of travelers from Philadelphia, Baltimore, New York and the South. This level of clientele would force the hotel owners to constantly update and upgrade their properties, and their bills of fare would have to keep up with the ever-increasing expectations.

**SECOND GRAND EXCURSION**
**To Cape May and Return !**
No Interference with Business Hours!
Fare only Four Dollars for the Round Trip!
**ALTERATION OF TIME!**
*Leaving Saturday Evening at 4½ p. m.*
Reaching home by 6 o'clock on Monday morning.

IN order to accommodate many who were unable to procure Tickets on Saturday last, owing to the limited number being sold previous to starting, ANOTHER EXCURSION has been arranged, leaving the Baltimore depot, Washington, on SATURDAY AFTERNOON, at 4½ o'clock, in the Regular Mail Train, connecting at Baltimore with the Special Express Train, which will leave the President street depot, Baltimore, at 7 o'clk precisely, for New Castle, Delaware, reaching there at 10 o'clock, p. m., where they will take the Company's swift and double-engine steamer ROBERT MORRIS, and proceed down the Delaware Bay to CAPE MAY, arriving there at 4 o'clock a. m., in time for EARLY MORNING BATH and BREAKFAST ON THE ISLAND!

Returning, the Robert Morris will leave Cape May at 6½ o'clock, p. m., Sunday evening, and arrive at New Castle at 10½ o'clock, connecting with the Express Mail Train from Philadelphia, reaching Baltimore by 3 o'clock a. m., and Washington at 6 a. m. on Monday.

An elegant *Breakfast, Dinner, and Supper* will be served up at the MERCHANT's HOTEL, Cape May, for the Washington passengers, at 50 cents each meal.

☞ *Tickets positively limited to fifty passengers from Washington,* AND NO MORE WILL BE SOLD THAN ISSUED.

Fare FOUR DOLLARS for the round trip.

☞ NO BAGGAGE CAR attached to this train. Passengers will be allowed to carry an ordinary Carpet Bag or Valise.

☞ TICKETS can be had at Brown's hotel, and, if not previously disposed of, at the depot, on the afternoon of the excursion.

au 1—3t

Advertisement for a special excursion to Cape May from Washington, D.C., for the 1855 season. For essentially a day trip to Cape May, there was an awful lot of traveling to be done. *Library of Congress.*

## THE HOTEL DINING ROOMS (AND THE MEALS SERVED) GET LARGER

Before the 1840s, the large houses and hotels of Cape Island were plain, unfinished and "barn-like." With the exception of the Mansion House, none of the hotels even had plastered walls. But as the summer

seasons continued to grow, new owners from outside Cape May began making changes.

Two brothers from Philadelphia, Captains Joseph and Benjamin McMakin, had purchased the Atlantic Hotel and decided to build a larger structure. Opened in 1842, the New Atlantic had four long tables that ran the length of the first floor. The Columbia House, which had been built in 1846, was purchased and remodeled by Lilburn Harwood in 1850 and 1851. Harwood brought in a Philadelphia architect for the redesign (a first for

Notice from the Tremont House (circa 1850) providing the hours when meals would be served and other rules and regulations. Don't let the kids sit at the first table! *Cape May County Historical Society.*

36

Cape May). The refurbished Columbia House had a large, clear-span dining room. Ayers Thompkins, who already had his confectionery shops here, built the United States Hotel and opened it up for visitors in 1851. The United States Hotel had its own spacious dining room that included a high ceiling.[14] These hotels were capable of accommodating several hundred diners each for meals. Each new hotel built seemed to be grander than the last.

With each of these dining rooms serving guests in the hundreds, it became quite a production to serve all of these people. Swedish novelist Frederika Bremer, while visiting Cape May in 1850, kept a journal of her experiences. She does her best to capture the clang and clamor of dining at Columbia House, where she was staying:[15]

> *The dinner hour is two, and what a noisy scene it is! There sit, in a large light hall, at two tables about three hundred persons, while a thundering band is playing, waited upon by a regiment of somewhat above forty negroes, who march in and maneuver to the sound of a bell, and make as much noise as they possibly can make with dishes and plates, and such like things, and that is not a little. They come marching in two and two, each one carrying a dish or bowl in his hands. Ring! says a little bell held aloft by the steward, and the dish-bearers halt. Ring! says the little bell again, and they turn themselves to the table, each one standing immovably in his place. Ring! and they scrape their feet forward on the floor with a shrill sound, which would make me ready to jump up if the whole of their serving were not a succession of scraping, and shrill sounds and clamor, so that it would be impossible to escape from the noisy sphere.*

Bremer seemed equally amused and aghast at watching two men sitting across from her (whom she nicknamed "the sharks") chow down corn on the cob:

> *It really troubles me to see how their wide mouths, furnished with able teeth, ravenously grind up the beautiful white, pearly maize ears, which I saw lately in their wedding attire, and which are now massacred, and disappear down the ravenous throats of the sharks. When I see that, I am convinced that if eating is not a regularly consecrated act—and is it not so in the intention of the grace before meat?—then it is a low and animal transaction, unworthy of man and unworthy of nature.*

Large, noisy dining rooms with hundreds of people made it hard for someone to get any kind of personal service from the waitstaff at any of the

Cape May hotels. There was one way, however, to get a waiter's attention: a little monetary persuasion. It became a well-known tradition to grease the palms of the servers. One visitor in 1844 said that to "throw a shilling or so at the head of everyone you meet" would be the "one infallible panacea that can cure crustiness on the part of servants at such places."[16]

## BILL OF FARE: DINNER AT CONGRESS HALL, JULY 20, 1851

Hanging on the wall in Congress Hall is a framed bill of fare from July 20, 1851. For those who study and enjoy historical menus, this is a great snapshot into Cape May's past, when the resort city was at its height:

*Soup: Turtle*

*Fish: Boiled salmon lobster sauce*
   *Baked rock sauce piquant*

*Boiled mutton, tongue, ham, corned beef, chicken caper sauce, egg sauce*

*Entrees: Stewed terrapin*
   *Veal cutlet tomatoe sauce*
   *Foie de veau wine sauce*
   *Barbecued bird en croute*
   *Chicken fricassee au vin*
   *Harricot de Mouton*

*Roast beef, lamb, veal, chicken, pig (substituted for duck), ham, champagne sauce*

The food items listed here did not have any prices attached. Even in 1851, Cape May was still operating under the American plan, which meant that the price you paid for your stay included meals and lodging. Alcohol, of course, was separate and hence those prices were provided.

The soup for the day was turtle, which was very popular in the Philadelphia region. It was also not a dish typically prepared in the home. As Miss Leslie stated in her *Directions for Cookery in Its Various Branches*, a very popular

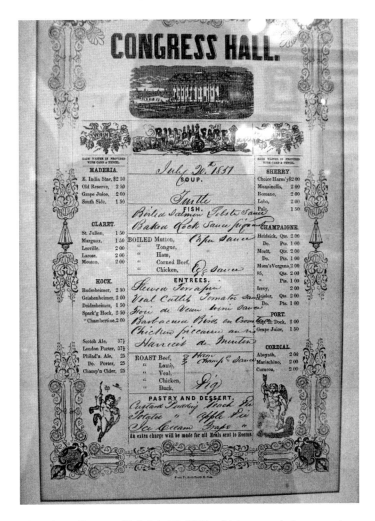

Menu from Congress Hall, July 20, 1851, which currently hangs on the wall at Congress Hall. There are no prices on the food items, indicating that this was on the American plan.

cookbook of the mid-nineteenth century: "When that very expensive, complicated, and difficult dish is prepared in a private family, it is advisable to hire a first-rate cook for the express purpose."[17]

Boiled meats and fish may not appeal to the twenty-first-century palate, but at this time in culinary history, they were quite commonplace. Mutton and beef tongue were also regular items that American diners would have seen on the tables of the day. As for egg sauce, this was made from boiled eggs that have been chopped and mixed with butter.

The entrées reflect the influence of French cooking on high-end dining; in fact, French cooking was high-end dining.

## White Diners and Black Servers: Food and Race

*It is necessary to make the interests of the servants and the proprietor one. And both parties must feel their identity. Thus a mutual good feeling becomes established; the interest if one becomes inseparable from the other; and the result is confidence and mutual dependence.*
—*Tunis Campbell,* Hotel Keepers, Head Waiters and Housekeepers' Guide

Toward the end of the eighteenth century, the movement away from slavery in the northern United States had already begun. The New Jersey state legislature had prohibited the further importation of slaves in 1786. This began what was called the manumission of slaves, which meant that slaves who reached a certain age would be freed. In 1804, the law allowed freedom for slaves who reached the ages of twenty-five for males and twenty-one for females. Slavery was fully abolished by the State of New Jersey in 1846.

But where would these newly freed slaves go for employment? Since most only knew of where they had labored, they tended to stay in the same area, working on the same farms and in the same households. Later on, when the large houses and hotels became part of the landscape, African Americans became the main source of labor to staff the cooking and serving positions.

When Thomas Hughes's Big House opened for business in 1816, how did he staff his venture? While we don't have a complete picture, a photo from the following century helps to provide some answers. In the August 13, 1921 edition of the *Cape May Star and Wave*, there appeared a snapshot of the dining crew at Congress Hall, headed by Chef Joseph Brobst. In the description of the image, it is said that this staff was the "first entirely white crew employed in the Dining Room of Congress Hall since its opening 106 years ago." Based on that statement, we can gather that African Americans had been working at Congress Hall since the beginning. So, not only was "Tommy's Folly" the start of the big business of tourism in Cape May, it was also the start of the uneasy yet mutually accepting agreement where a predominantly white sea-bathing audience would be served by a predominantly black cooking crew and waitstaff.

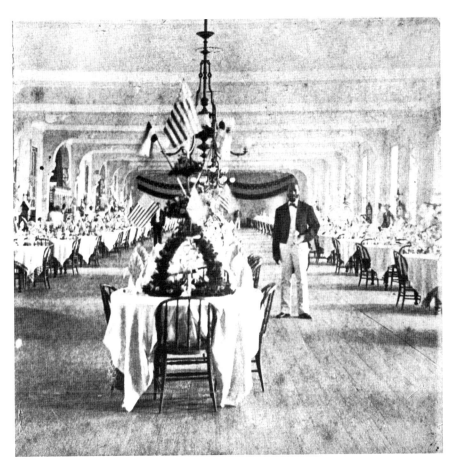

An amazing picture taken from a dining room in Cape May from the late nineteenth century. It is believed to be Congress Hall, the one that burned down in the fire of 1878. *Richard Gibbs.*

While it is hard to pinpoint the cooks who toiled in the hot kitchens of the Cape May hotels, we do know of one rather famous cook. It was not her cooking that was noteworthy but rather her other work that would make her legendary. In the summer of 1852, Harriet Tubman—yes, that Harriet Tubman—worked as a cook in Cape May to help raise money for her slave-freeing operations. (Some sources believe that she specifically cooked in the kitchen of Congress Hall that summer, but that cannot be verified.) She cooked not only in hotels but also for families.[18] Keep in mind that Cape May was still a very popular resort for those south of the Mason-Dixon line. The image of an affluent slave-owning southern gentleman dining on a meal prepared by a person plotting to free slaves is delicious irony indeed.

There were incidents, to be sure. In Swedish novelist Frederika Bremer's journal from her visit in 1850, she noted of "a great battle in one hotel between the black servants and the white gentleman, which was caused some bloody heads."[19] Two separate incidents in that same 1850 season caused a bit of a stir with visitors from Baltimore: one at a hop at the Atlantic Hotel involving a man from Baltimore and a waiter that became a full-fledged brawl (a number of waiters refused to serve the next day) and the other between a man from Nashville and a porter over carrying a bag that resulted in the porter getting cut on the head by a tumbler from a bar.[20]

In August 1856, at the Mount Vernon Hotel, a waiter named Joshua Gibbs was making his way through the hotel when he was nearly struck by a tumbler that had been thrown at him. The tumbler had come from a group of young white men who were sitting one floor above. The waiter turned to the group and said that the act of throwing the glass was not fitting of a gentleman. This comment sent one of the young men into a rage, and he came down the stairs quickly to confront Joshua Gibbs. The man was armed with a gun and a dirk (a long dagger), and in the altercation he stabbed the waiter. The wound was not fatal, but it created quite a stir among the other waiters, who were incensed over the incident.[21]

The ugliest of altercations took place in 1865, when a man named Michael Sullivan, a white gentleman, was killed by Charles Wilson, an African American who worked as a cook at one of the hotels. Sullivan, who was intoxicated and was having trouble walking straight, did not take kindly to Wilson and his friends asking him why he was not able to walk straight. Words led to fists and then to a brick being thrown at Sullivan, knocking him down. Then Wilson grabbed a fence pailing and beat the drunken man until he was dead.[22]

But there was also praise for the men who worked the dining room floor. Many of the waiters were seasoned professionals who were brought from top hotels in Philadelphia; Baltimore; Washington, D.C.; New York; and Boston to Cape May to work for the two-month summer season. Tunis Campbell, a head waiter for hotels in New York, had his book on a proper system of running a hotel and dining area published in 1848—a rare achievement for an African American of the era. The book is nothing short of fascinating, with detailed instructions and diagrams on how to keep a large dining room running smoothly.

It was said that Benjamin Harrod, the head waiter at the New Atlantic Hotel, was the embodiment of elegance and grace. He once announced that a concert that was to take place that evening had to be postponed.

The announcement was of such quality and dignity that it brought applause from those who heard him.[23]

Matthias Johnson, the head waiter at Congress Hall during the 1860s, had worked in hotels at resort towns such as Saratoga, Long Branch and Atlantic City before coming to Congress Hall. He kept things moving in an orderly fashion in the dining hall by the use of signs—the noise of several hundred patrons would have made shouting useless.

Some of the hotels allowed their waitstaff to throw their own hops and balls at their place of employment. In 1872, Congress Hall and the Stockton had hops for the waiters in August. The ladies and gentlemen in attendance were dressed to impress. Entertainment was provided by the Excelsior Colored Band from Philadelphia for both events. And grand meals were served to the attendees. Those who happened to be staying at the hotels at the time watched from a distance as amused spectators. "Mr. Cake showed his superior judgment by allowing the colored people the use of his dining room last night," reported the *Cape May Ocean Wave*, speaking of the hop at Congress Hall and its proprietor. "Prejudice is the coin of fools, even then it is counterfeit."[24]

Prejudice may have been the coin of fools, but race separation was still the currency of the day. African American beachgoers had to enjoy the waves at their own separate area. Hotels such as the Banaker House, run by George Woodford on Lafayette Street, and later the Hotel Dale, whose proprietor was the well-regarded caterer from Philadelphia Edward W. Dale, were the welcome havens for meals and a place to sleep. It would be many more decades before visitors of every color would be welcomed at every hotel, restaurant and beach spot.

## End Story: The Mount Vernon Hotel

The height of Cape May's status as a premier seaside resort was to be cemented by the building of the Mount Vernon Hotel. At the time of its opening for the summer season in 1854, it was the largest hotel in the world. When fully constructed, the Mount Vernon Hotel would have been able to accommodate two thousand guests. The hotel was to be run by Job Taber, who had successfully run the American Hotel in New York. The Mount Vernon was a clear indication that Cape May wanted to attract the New York crowd, which spent its summer season at Cape May's rival to the north, Long Branch.

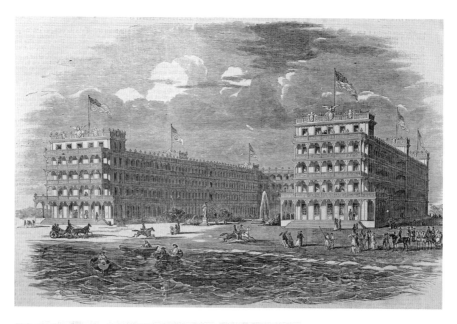

# MOUNT VERNON HOTEL,
## Cape May, New Jersey.

THE above House has been completely finished and furnished, and will comfortably accommodate 1,500 guests. The house is situated within the city, standing by itself on probably the best beach for bathing in the world The house is upward of 800 feet in length, the dining room is 450 feet. Altogether, the MOUNT VERNON HOTEL affords the coolest and most delightful retreat in the world.

Families of six persons and upwards can be accommodated with private tables, having their meals furnished at any hour agreeable to them. An ordinary will also be set at regular hours for those who are not in parties, and who may prefer a Table d'Hote.

A large number of private Dining Rooms have this season been added, for parties desiring to be strictly private.

An Artesian Well has been bored nearly 200 feet in depth, and furnishes pure soft water throughout the house.

Large and commodious stabling have been added.

The Hotel has every modern improvement, indeed, every thing has been ordered to give comfort and pleasure to the guests.

A full Band of Music will be in attendance during the whole season.

Letters addressed to the proprietors, directed to Cape Island, Cape May, N. J., will be promptly answered.

SAMUEL B. WOOLMAN & CO.,
may 25—2w*                                    Proprietors.

*Above*: Drawing of the Mount Vernon Hotel in the *Illustrated London News* in 1853, as it would have appeared when fully constructed. Fire destroyed this massive hotel in 1856. *Cape May County Historical Society.*

*Left*: Advertisement for the Mount Vernon Hotel in 1855, emphasizing the dining aspect of the hotel. Dining at all hours was now available, as well as the traditional set-time dining in the ordinary. *Library of Congress.*

As far as the dining room, this would have truly been a wonder to see. Stretching 450 feet lengthwise (or one and a half football fields) and 60 feet in width, the dining room could seat three thousand people! But unlike the long tables and communal dining that was typical of the day, families and groups of six people or more were able to dine at their own table in their own privacy. European-style dining on a grand scale, indeed.

In 1853, a sketch of the completed Mount Vernon Hotel was published in the *London Illustrated News* along with a description of what the hotel was going to be. It is brilliant in its nineteenth-century bombast. Here is the section on what visitors would expect when dining at the Mount Vernon:[25]

> *Nothing is carved at the table; but everything that the most epicurean diner could wish for, provided it be in season, can be had in the* salon à manger. *At the Mount Vernon Hotel there are the best poultry and the best joints to be found in the Union. The soup is sure to be unexceptionable; the fish is of the rarest, and the fruits are of the finest. In this respect it is unrivaled by any Parisian restaurant. Add to which the cookery would do honor to a Ude, a Francatelli, or a Soyer. Lucullus would have said he had never dined better in his life, had he lived to dine at the Mount Vernon Hotel; and Colonel West, the proprietor is not the man to allow his guests to look back with regret at the good fare they may have left behind them elsewhere.*

Tragically, the Mount Vernon would only stay open for three summer seasons. As the final additions were being made after the 1856 season, a fire broke out and consumed the entire hotel. Nothing of its scale would ever be attempted again in Cape May.

Chapter 3
# The Place of Places for an Epicure

*Cape May is the place of places for an epicure. All our great hotels...have become famous justly for their cuisine. Everything that the world gives in the edible line is to be found in the bills of fare of our Cape May hotels—aye and on their tables.*
—Cape May Ocean Wave, *August 24, 1878*

Even after the loss of the palatial Mount Vernon Hotel, Cape May continued to be one of the great seaside resorts in the eastern United States for much of the latter half of the nineteenth century. Presidents made it a destination to enjoy the seaside, mingle with the people and enjoy fine meals and celebratory evening hops. Thousands of visitors continued to make the trek by boat, train and carriage to enjoy the coolness of Cape May. But there were also trials and conflicts that would reshape this resort town in ways that we can experience today. And through it all, food was part of the story, and new players from other parts of the world would have their influence.

## Ordinaries, Eating Houses and Restaurants

In 1834, Thomas F. Gordon published his *Gazetteer of the State of New Jersey*. In this inventory of the entire state, Gordon broke down each town and community by mill, distillery, tavern, horse—you get the idea. But there is one word you will not find in this book, and that is the word *restaurant*.

In the mid-nineteenth century, a restaurant was not simply a place to eat as we think of it in today's terms. A restaurant was a distinctive style of dining that had come over from Europe. Born in Paris in 1769 (of course, from the French!), the restaurant style of dining had evolved from its simple beginnings of offering broth-like restoratives to having individual dining that catered to individual tastes. But in America, this was still a relatively foreign (pun fully intended) concept in Gordon's time.

Although some places in the United States were offering bills of fare that allowed diners to choose their own options before the late 1820s, the Tremont House in Boston is considered to be the first to have served "French service" meals in 1828, where people could dine at individual tables. The next leap in the restaurant movement happened in New York, where two Swiss immigrants who had opened a confectionery shop in 1827 decided to serve meals in a French restaurant style. The year was 1831, and the name of the restaurant was Delmonico's—it would be considered the finest restaurant in the United States for almost a century.[1]

As the major city of industry and commerce in the nineteenth century, Parisian-style restaurant dining would come to Philadelphia as well. In turn, the hoteliers and entrepreneurs from this city would bring these concepts to Cape May. At the height of its status as one of the premier seaside resorts

# CONGRESS HALL
# RESTAURANT
## ALL DELICACIES
## OF THE SEASON
### SERVED AT ALL HOURS.

Congress Hall keeping with the times in 1865, declaring that its restaurant is serving at all hours in the *Cape May Ocean Wave*.

in the country, Cape May would be in a state of continuous transition at its dining tables.

An advertisement by the Centre House in the *Philadelphia Inquirer* during the summer of 1854 mentioned "a Restaurant and Ordinary attached to the hotel, and visitors can be accommodated at all hours with every delicacy of the season." This is one of the earliest mentions of the word *restaurant* in Cape May appearing in print.

By 1857, you had establishments such as the United States Hotel advertising a "Table de Hote" to be served at a specific time, as well as "private tables for parties and families at any hour." Even though the dining halls at the hotels continued to expand, they also had to cater to a clientele that wanted the option to dine the Parisian way. Congress Hall—which had built a magnificent dining room spanning two hundred feet in length, forty-five feet in width and sixteen feet from the floor to the ceiling[2]—would also have two restaurants available, one for the ladies and one for the gentlemen,[3] to accommodate those who did not want to have their meals at a set time.

## Early Restaurants and Eating Saloons

While it was the preference of the visiting sea bathers to dine at the great hotels of Cape May, not everyone could find a seat at these tables. To fill the gap, local eating saloons and restaurants began to appear on the scene.

When we hear the word *saloon*, we most likely conjure images of dusty bars of the Old West with swinging doors, piano players and seedy characters drinking alcohol that could remove the paint from the wall. But the word was used to mean a large room for a specific activity. Ice cream was served in an ice cream saloon. Amusements such as bowling and archery took place in bowling saloons and archery saloons, respectively. And places that served food not in the French style of restaurant dining were called eating saloons.

Mrs. R.M. Bickom, who ran two bakeries (one on Washington Street and one on Lafayette Street), opened an eating saloon on Washington Street above the Washington House for the 1860 season. The saloon served breakfast from 6:30 a.m. to 7:30 a.m., which gave customers plenty of time for sea bathing; dinner from noon to 2:00 p.m.; and supper from 6:00 p.m. to 7:00 p.m.

In addition to being the director of the West Jersey Railroad and being behind the building of the Stockton Hotel, William J. Sewell purchased the

## MRS. R. M. BICKOM'S
# BREAD, PIE AND CAKE.
## BAKERY.

THE SUBSCRIBER begs leave to call the atten-
tion of visitors and others, to her Bread, Pie &
Cake Stores, where she intends keeping constantly
on hand, a large supply of Fresh Baker's Bread,
Pies, Hot Rolls, Rusks, Cakes of all kinds, and
Confectionery, &c., &c.

From her long experience in the business, and
having the best of Bakers and Pastry Cooks em-
ployed, she feels satisfied that satisfaction can be
given to all who may favor her with their patron-
age.

STORES in Washington street, opposite the Visi-
tors' M. E. Church, second door above the Wash-
ington House, and in Lafayette street, next door to
the Cape May County Bank Building.

EATING SALOON.—In connection with the
above th subscriber has also opened an Eating
House, in Washington st., above the Washington
House, where MEALS are provided at all hours, and
on reasonable terms.

MRS. R. M. BICKOM.

Cape Island, June 20th, 1860.

An advertisement in the *Cape May Ocean Wave* for Mrs. R.M. Bickom's bakeries, as well as the new eating saloon venture.

area known as Poverty Beach and built a new dining establishment called the Fish House Restaurant. Open for business in 1869, the Fish House could cater to many types of clientele. For those who wanted to be served a meal, the Fish House had large tanks where fresh catches of sea bass, porgies, blue fish, mackerel and sheepshead were ready to be cooked over hot coals. The Fish House also maintained its own fishing vessel and tackle for those who wanted to catch their own meal.

"To get a nice oyster stew after the day's labors are over, turn thy steps towards Snyder's Decatur Street restaurant," announced the *Cape May Ocean*

SEWELL'S POINT FISH HOUSE,

Cold Spring Inlet, Cape May, N. J.

——————

PLEASURE AND FISHING BOATS TO HIRE.
Meals and Refreshments served at short notice, and the best attention paid to the wants of fishing parties and visitors to the Inlet generally.
Wines, Liquors, Cigars, etc., of the choicest brands.

H. W. FAWCETT,

71 1m                                    PROPRIETOR.

In 1869, the Fish House opened at Sewell's Point. Whether you caught your own or just picked from its selection, it would be able to prepare a meal for you. *Library of Congress.*

*Wave* in November 1872. Isaac Snyder opened a restaurant on Decatur Street in the early 1870s and became a regular part of the dining scene for many years. Snyder's establishment was open year-round, so it catered to the locals just as much as to the summer visitors.

Isaac Snyder caused some confusion for the city council in 1874 when he applied for a tavern license for his restaurant. His application was determined to be out of order, as he didn't need a license to run his restaurant.[4] The council must have decided otherwise later on, or Snyder began to serve alcohol, because the licenses granted to taverns in 1880 included Snyder's restaurant. Eventually, the restaurant was taken over by his wife, who continued to serve "a good dinner for 50 cents"[5] through the 1880s.

John Lansing established a restaurant in 1874 on the corner of Washington and Jackson Streets that would be a fixture in Cape May for decades.

## What the Visitors of Cape May Ate

As busy as the summer seasons could get in Cape May, one would think it would be quite a task to calculate how much food was consumed by the shore town's visitors each day. And yet one anonymous steward made

such an attempt to quantify this during the 1872 season. Here is what he came up with, and he assured the reader of the local paper that "the figures are correct":[6]

*Beef, 5,972 pounds*
*Mutton, 2,327 pounds*
*Lamb, 596 pounds*
*Veal, 689 pounds*
*Ham, 1,148 pounds*
*Small Fish, 2,700 pounds*
*Sheepshead, 739 pounds*
*Chickens (pairs), 1,148; average weight per pair, 3 to 3½ pounds per pair*
*Oysters, 230 bushels*
*Clams (single), 5,000*

This list does not even count the amount of produce consumed. And the poor steward probably couldn't even begin to comprehend the liquid volume of alcohol that was imbibed from July to September.

# Presidential Visits

The prominence of Cape May as a summer destination could not be more emphasized than by the people who came to visit. The tables, not to mention the beaches, of Cape May became a stopping point for a number of men who resided at the White House in the mid- and late nineteenth century.

The first to make the trip was President Franklin Pierce, who stayed at Congress Hall in June 1855. Not the most popular of presidents, Pierce's stay in Cape May was ridiculed by the press, claiming that the chief executive was vacationing while there was work to be done in Washington (a common refrain that gets repeated even to this day!).

President James Buchanan also stayed at the famous seaside resort in 1859 during his term at the White House. Buchanan returned to Cape May in 1867, long after his days as president. There he dined at the Columbia House during his stay that summer. In a letter to his niece, the former president wrote, "Mr. Bullitt of Philadelphia gave me a dinner the other day, which I only mention from the awkward situation in which I was placed by not being able to drink a drop of wine."[7]

Although he is more known from his time spent at Long Branch, President Ulysses S. Grant also made stops at Cape May during his presidency. In July 1869, President Grant spent three days at Cape May, staying at the Stockton House while also enjoying the hospitality of the United States Hotel. Grant attended a reception for the Gray Reserves at Congress Hall, as well as grand regimental ball at Stockton House.

President Grant returned to Cape May for the summer season of 1875 as an invitee to witness the Cape May Regatta yacht race. He stayed at Congress Hall during his second visit, making sure that his meat was cooked to a crunch and refusing to eat any kind of poultry.[8]

President Chester Arthur made a very brief visit to Cape May in July 1883, shaking hands with a multitude of bathers at Congress Hall.

*Top*: President Franklin Pierce, the first president to visit Cape May, came with his wife to stay at Congress Hall in 1855. *Congress Hall.*

*Left*: President Ulysses S. Grant visited a few of the many hotels in Cape May during his visits in 1869 and 1875, but Long Branch would be his favorite place on the Jersey Shore. *Congress Hall.*

The most well known, and somewhat controversial, extended stay at Cape May by a president was when President Benjamin Harrison and his wife stayed during the summer seasons of 1889, 1890 and 1891. President Harrison had strong ties with John Wanamaker, a wealthy businessman from Philadelphia who was a financial backer of Harrison's presidential campaign. Upon winning the presidency, Harrison appointed Wanamaker as postmaster general. In 1889, the Harrisons stayed at the Wanamakers' cottage for one week.

The following season had its controversy. Wanamaker built a cottage for the president at a cost of $10,000. Harrison, seeing this as unethical, had to refuse the gift. The compromise was that the cottage was given to the First Lady instead. But that didn't stop the press from intimating that the president was being bought. The Harrisons summered at the new cottage just the same, although the president would send Wanamaker a check for the cottage.

President Benjamin Harrison spent three summers at Cape May, including occupying the first floor of Congress Hall in 1891 and making it the "Summer White House." *Congress Hall.*

In 1891, President Harrison summered at Congress Hall, renting out the entire first floor. His residence was dubbed the "Summer White House."

As far as eating, President Harrison loved oysters and, according to his wife, would have them three times a day if he could.[9]

# Pure Cape May Coffee

Even though the farmers of Cape May never grew coffee beans of any kind, there is a short tale to tell about some railroad workers and brew served to them by a local woman.

The railroad finally made its way to Cape May in 1863, with the first line called the Cape May and Millville Railroad. The line finally connected Cape May with Philadelphia by rail, having spotted Atlantic City a nine-year head start in this mode of transportation. While the railroad line was being constructed, a group of railroad workers was given a ride to the construction site thanks to a married couple that resided locally.

During the trip, the wife served the men her own special brand of coffee, "Pure Cape May Coffee," as it was described in the recollection of the daughter. And what was in Cape May Coffee? It consisted of "sweet potatoes, cut into small cubes, roasted hard and ground…then, adding essence of coffee."[10]

This account is the only mention found for this kind of concoction, which sounds like an attempt to stretch one's supply of coffee.

## Cape May During the Civil War

Although Cape May was not involved in any direct conflict during the Civil War, the area felt many effects from the War Between the States. First of all, travelers from the South stopped coming and did not hurry back right after the conflict had ended. The potential for New Yorkers to come to the Cape also dwindled, with steamships being commandeered by the Union army. Some hotels even stayed closed during the summer seasons.

There was also a human toll, as thirty-two men from Cape May County lost their lives while fighting for the Union army during the conflict. Volunteers saw action in some of the more famous battles of the Civil War, including at Fredericksburg and Gettysburg.[11]

The big story that captured the minds and hearts of those from Cape May was the ordeal involving Colonel Henry Sawyer, who was captured by Confederate forces and held prisoner. As retaliation, Sawyer was to be executed but was saved due to the work of President Lincoln. Sawyer returned to Cape May and eventually became a hotel owner. The hotel he opened in 1876 would make it through the ages to today, and it is beloved by many who make the trip to Cape May: the Chalfonte.

If you believe that crass commercialism is a modern invention, please refer to the following advertisement for a local store that appeared in the *Cape May Ocean Wave* in the last days of war as the Union army took the

capitol of the Confederacy: "Richmond Has Fallen, and So Have the Prices of Our Goods! SUGAR which formerly we sold at 30 cents, we will now sell at .18."[12]

## The Stockton Raises the Stakes

Opening in 1869, the Stockton Hotel, a venture of John C. Bullitt and William J. Sewell, was soon recognized for its culinary prowess. It had two dining rooms, and only twelve people were allowed to sit at each table. Every table had its own plate of butter, as well as pitchers of water and milk. The oysters served at the Stockton were reported to be of such quality that

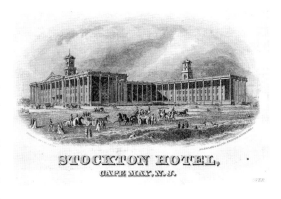

A print of the Stockton Hotel, built by the West Jersey Railroad, which became the place for dining in the 1870s. *Richard Gibbs.*

they tempted "the penchant of the most precise epicure. A half dozen after bath is a luxury that can be understood only by the experienced."[13]

One modification that the Stockton made was an ordering-by-number system. This allowed the diners to order their entrée by providing the number that corresponded to their choice. A writer for the *New York Times* noted that a no. 2 was *Cervelles de Veau à la Tartar*, the no. 5 was *Tendron à la Dufour* and a no. 7 was *Macaroni à la Milanaise*.[14]

The Stockton also made the claim that it was the first place that served ice in each glass. While such a claim can be hard to substantiate, if it was true, it is an important milestone in dining. How could ice in a glass be so important, you might ask? Consider this: even to this day, if there is one thing about dining out in America that differs greatly from dining in Europe, it is being served drinks with ice. In the United States, this is commonplace; in Europe, this is rare. One could make the argument that serving ice in a glass for drinks made American dining distinct from European dining.

## Lunch for the Ladies

To this point, the three meals of each day were breakfast in the early morning, dinner in the early afternoon and supper in the evening. Then along came this new idea called "lunch," which was seen as a light meal for the ladies. But the women were not losing any of the other meals, so they were actually having four meals for the day.

At Cape May during the 1870s, hotels began to serve a lunch for the ladies between the hours of 11:00 a.m. and 2:00 p.m. And it was for the ladies only; for the gentleman who could not wait until dinner, there were cold snacks at the bar, or they would have to go to one of the new-styled restaurants attached to the hotel that served meals à la carte (and not part of the cost of room and board).[15]

## John S. Corson:
## A Man of Many Culinary Trades

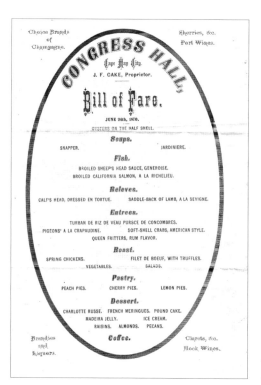

The Corson family name traces its roots in Cape May back to the early landowners in the late seventeenth century. One of their descendants, John S. Corson, was a very busy man in the food and hospitality trades. We know that he had a tavern license as early as 1852. By 1862, he had opened his own hotel in Cape May called the Ellsworth House on the corner of Washington and Ocean Streets. He supplied

Menu from Congress Hall dated June 24, 1870. How did that California salmon get on the menu with all the wonderful fish that could be had locally? *Richard Gibbs.*

56

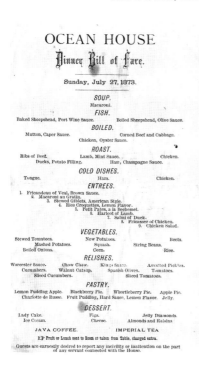

OCEAN HOUSE
Dinner Bill of Fare.

Sunday, July 27, 1873.

**SOUP.**
Macaroni.

**FISH.**
Baked Sheepshead, Port Wine Sauce.    Boiled Sheepshead, Olive Sauce.

**BOILED.**
Mutton, Caper Sauce.    Corned Beef and Cabbage.
Chicken, Oyster Sauce.

**ROAST.**
Ribs of Beef.    Lamb, Mint Sauce.    Chicken.
Ducks, Potato Filling.    Hair, Champagne Sauce.

**COLD DISHES.**
Tongue.    Ham.    Chicken.

**ENTREES.**
1. Fricandeau of Veal, Brown Sauce.
2. Macaroni au Gratin.
3. Stewed Giblets, American Style.
4. Rice Croquettes, Lemon Flavor.
5. Petit Pates, a la Bechemel.
6. Haricot of Lamb.
7. Salmi of Duck.
8. Fricassee of Chicken.
9. Chicken Salad.

**VEGETABLES.**
Stewed Tomatoes.    New Potatoes.    Beets.
Mashed Potatoes.    Squash.    String Beans.
Boiled Onions.    Corn.    Rice.

**RELISHES.**
Worcester Sauce.    Chow Chow.    Kings Sauce.    Assorted Pickles.
Cucumbers.    Walnut Catsup.    Spanish Olives.    Tomatoes.
Sliced Cucumbers.    Sliced Tomatoes.

**PASTRY.**
Lemon Pudding Apple.    Blackberry Pie.    Whortleberry Pie.    Apple Pie.
Charlotte de Russe.    Fruit Pudding, Hard Sauce, Lemon Flavor.    Jelly.

**DESSERT.**
Lady Cake.    Figs.    Jelly Diamonds.
Ice Cream.    Cheese.    Almonds and Raisins.

JAVA COFFEE.    IMPERIAL TEA

☞ Fruit or Lunch sent to Room or taken from Table, charged extra.

Guests are earnestly desired to report any incivility or inattention on the part
of any servant connected with the House.

**WINES.**

| Champagnes. | | Santernes. | |
|---|---|---|---|
| Rhoderer's Carte Blanche | 4 00 | Haut Sautern, qts | 2 00 |
| " " pts | 2 25 | " pts | 1 00 |
| " Dry Sillery, qts | 4 00 | Latour Blanche | 2 50 |
| " " pints | 2 25 | | |
| G. H. Munm's Extra Dry, qts | 4 00 | **Sherry.** | |
| " " pts | 2 25 | Table | 1 00 |
| G. H. Munm & Co. Dry Verzenay | 3 50 | Vallette | 1 00 |
| " " pints | 2 00 | Harmony | 2 00 |
| Piper Heidsieck | 3 50 | Superior Pale Sherry | 2 00 |
| " pints | 2 00 | | |
| Carte d'Or, qts | 4 00 | **Brandy, &c.** | |
| " " pts | 2 25 | Martel | 3 50 |
| **Clarets.** | | Old Hennesy | 3 50 |
| Table | 75 | Monogram Whiskey | 2 00 |
| St. Julien, Superior, qts | 1 25 | | |
| " " pts | 75 | **Ale and Porter.** | |
| Floirac, qts | 5 50 | Bass & Co.'s Ale | 40 |
| " pts | 1 25 | B. Younger's Scotch Ale | 40 |
| **Rhine Wines.** | | Brown Stout | 40 |
| Hockheimer | 2 50 | Philadelphia Porter and Ale | 15 |
| Deidesheimer, 1865 | 1 50 | | |
| | | **Domestic Wines.** | |
| **Port** | | Dry Catawba | 1 50 |
| Table Port, very fine, qts | 2 50 | Sweet Catawba | 1 00 |
| " " pts | 1 50 | | |

*CORKAGE, ONE DOLLAR PER BOTTLE.*

Each Waiter is provided With Wine Cards and Pencil.

*Above*: Bill of fare from the Ocean House dated July 27, 1873. Notice that the entrées are numbered, which would have allowed diners to order by number to simplify things for the waiters. *Richard Gibbs.*

*Right*: Christmas Day menu for the Arlington Hotel in 1875. Notice the mulligatawney soup at the top of the menu, a decidedly non-French dish.

**Menu.**

SATURDAY, DECEMBER 25, 1875.

**SOUP.**

Mulligatawney.    Printaniere.

Bluefish, baked, sauce Duxelle.

Boiled Leg of Mutton, Caper sauce.    Bœuf à la Mode.    Plain Lobster.    Ham.
Boiled Corned Beef and Cabbage.    Middling. – Boiled Chicken, Egg sauce.
Boiled Turkey, Oyster sauce.

Roast Ribs of Beef.    Roast Turkey, Giblet and Cranberry sauce.
Roast Saddle of Southdown Mutton.    Roast Pork, Apple sauce.
Roast Loin of Veal.    Roast Spring Chicken.    Ham, Champagne sauce.

Boiled and Mashed Potatoes.    Celery.
Succotash.    Cabbage.    Boiled Rice.    Mashed Turnips.    Pickled Beets.
Boiled Onions.    Stewed Tomatoes.    Green Corn.    Lima Beans.
Macaroni, au Gratin.    Sweet Potatoes.    Squash.

Terrapin, stewed, Maryland style.
Caille Barde, aux Petits Pois.    Paupiette de Veau, en Macedoine.
Chevaliere de Volaille, aux Champignons.

Canvas-back Ducks, Currant Jelly.    Saddle of Venison, Currant Jelly.
Galantine de Dinde, à la Gelée.
Paté de Gibier, aux Truffes.    Mayonaise de Volailles.

Pickles.    Olives.    Horse Radish    Centennial sauce.    Tomato Catsup.
French Mustard.    Mushroom Catsup    Walnut Catsup.

Fruit Pudding, Hard and Wine sauce    Pumpkin Pie.    Mince Pie.
Macaroons.    Fruit Cakes.    Cream Kisses.

Vanilla Ice Cream.    Champagne Jelly.    Burnt Almonds.
Apples.

Nuts.    Havana Oranges.    Raisins.

**COFFEE.**

his guests with "the choicest seasonal delicacies" and kept his bar well stocked.[16]

But Corson was also adept at producing culinary items, as well as having them served at his hotel. In December 1864, the local paper reported on his abilities as a butcher. Not only was Mr. Corson able to kill three large hogs, weighing between 415 and 456 pounds, but he also made sausage out of them as well.[17]

Later on, John S. Corson would become proprietor of the Tontine Hotel, which had an oyster restaurant serving them by the plate or half shell—or in quarts or gallons if you really had a craving.

## The Fires of 1869 and 1878

Large wooden structures and strong ocean breezes made for a bad combination in Cape May. In August 1869, a fire in a store on Washington Street quickly spread and burned down several buildings, including the United States Hotel and Atlantic Hotel, as well as a number of saloons, bakeries and other eating establishments.

But it was the fire of 1878 that would forever change Cape May. Starting at the Ocean Hotel on a November morning, the fire consumed forty acres of property over a span of eleven hours. Congress Hall was next in the path of the blaze and was completely destroyed. Columbia House would be the next to go up in smoke, followed by the Centre House. In all, six hotels, twenty cottages and three restaurants were destroyed by the inferno.

After the 1878 fire, Cape May was a city in ruins. It now faced the monumental task of having to rebuild in time for the summer seasons to come. It was also now facing stiff competition from the upstart town of Atlantic City and other communities along the Jersey Shore.

But rebuild Cape May did. A new Congress Hall, built in brick, was completed in time for the summer season in 1879. Others followed suit, but the newer hotels and cottages would be smaller in size. The days of the grand hotels in Cape May appeared to be over.

# The Immigrant Influence

After the Civil War, Cape May began to see a change in its inhabitants. Having been a relatively closed community of descendants from those early yeoman farmers, the 1860s and 1870s saw a growing diversity as Germans, Italians and other European immigrants made Cape May their home—or, at least, their summer business enterprise.

Polish-born Adolph Proskauer became a successful Philadelphia restaurateur in the 1860s before opening a European-plan restaurant and hotel called Maison Dore on the corner of Washington and Jackson Streets for the 1869 and 1870 seasons in Cape May. His bill of fare received high marks from the local papers, which noted that "Proskauer is the prince of Cape May caterers. The dish that can't be served at his establishment has not yet been invented."[18]

Proskauer's height of success would come during the 1876 Centennial Exhibition in Philadelphia, when his restaurant at Belmont Mansion in Fairmount Park was considered the primary place to dine. But his success would not last. He eventually had to give up his restaurant at Belmont Mansion in 1882. In 1884, bad times and failing health led Proskauer to make two attempts to commit suicide. One of those attempts took place at the Lafayette Hotel in Cape May while staying there in June. Only a last-minute intervention from the hotel manager would spare Proskauer's life.[19]

William Essen emigrated from Germany in the 1850s and established a bakery in Philadelphia with several employees under his watch. Like many enterprising Philadelphians, he, too, established a summer location in Cape May. But unlike many of his peers, Essen would eventually move to Cape May in the early 1870s and make it his business home year-round.

Expanding on his bakery, Essen included homemade ice cream (using cream brought in from farms in Pennsylvania) and a restaurant. He also had his own bread truck to make deliveries. The Essen name would be at home at 524 Washington Street into the early twentieth century, where the story continued.

Italian immigrants also began to make their way to the Jersey Cape in the late 1860s and early 1870s. Caramille Mirabella, born in Naples, is believed to have been the first licensed tavern keeper of Italian descent in Cape May. Mirabella's Hotel was open for guests before 1870. Some Italian immigrants settled in Pierce's Point just north of Cape May, where the Baltimore Oyster

Company had a plant. Workers would open the oysters and have them shipped off to—you guessed it—Baltimore. Italian-born vendors began to open up shops on Washington Street, selling fruits and vegetables as well as macaroni and olive oil.

## Temperance and Anti-Saloon Movements

In the first county court of records in 1693, one of the first issues to be addressed was the sale of alcohol. The issue was brought to the attention of the court by local resident Elizabeth Crafford:[20]

> *The grand jury, upon complaint made by Elizabeth Crafford, and we have taken it into consideration, and we find that no fariner ought to rate ale or other strong drink to ye inhabitants of Cape May, except they have a lycense for so doing. So the court orders that no person shall sell liquor without*

A bill from the Atlantic Hotel in 1875. The hotel's stance on alcohol was made clear by the "No bar" printing in its header. *Cape May County Historical Society.*

*lycense, and that forty pounds be raised by tax to defray expenses, with a proviso that produce should be taken at money price in payment.*

Since the formation of Cape May as an entity, there have existed issues regarding alcohol. Regardless of whether the alcohol was sold by a fariner or not, alcohol caused its own set of problems. Rum from the West Indies led to concerns over drunkenness during the first half of the eighteenth century.

Although a bar stocked with the finest liquors that could be had from the Philadelphia market was used as an enticement by many hotels in Cape May, some did not go that route. The McMackin brothers kept their Atlantic Hotel dry, prominently stating that their hotel did not have a bar. Aaron Garretson's National Hall also promoted a family-like atmosphere and did not serve alcohol. In 1843, the Court of Quarterly Sessions established a Temperance Tavern bill and set rates for those taverns that did not serve alcohol.

A reporter for a Philadelphia paper wrote about "the number of small gin-shops which are licensed by the authorities. This evil, unless checked, cannot fail to be productive of much mischief. It cannot be obviated by excessive license fees, for the parties engaging in the business willingly pay them."[21] The local papers were also critical of what they believed to be rampant drinking, saying in 1870 that Cape May had "fifteen taverns too many on the Island."[22]

In 1874, 150 women of the Cape May community sent the city council an impassioned petition against issuing tavern licenses, but to no avail. Local and traveling ministers preached against drinking. National Hall played host to temperance meetings. A Prohibition Party was formed, attempting to put the question up for a national debate.

But it was the Anti-Saloon League, formed in 1893, that would get real results. Its movement was based on changing the laws on a local level, instead of trying to do so on a national level. Its influence had certain effects. Not wanting to associate their places of business with the bad connotation of a saloon, ice cream places started calling themselves "parlors." Eating saloons became "restaurants."

Eventually, the question became a national issue, with the culmination being the passing of the Eighteenth Amendment in 1920. Prohibition was the law of the land, and it brought its own set of problems.

# Bill of Fare: Stockton Hotel, August 7, 1885

*Oysters on Shell*
*Clam Chowder a l'Americaine*
*Consomme Italian Paste*
*Escalope of Lobster*

*Broiled Sea Bass, Hollandaise*
*Baked Filet of Sole au Vin Blanc*
*Pommes de Terre, Chateau*

*Beef Braise Flamande*
*Ham, Currant Jelly Sauce*

*Sirloin of Beef, Napolitaine*
*Veal Pie, Vermont Style*
*Stuffed Tomatoes, a la Creole*
*Macaroni Milanaise*

*Claret Punch*

*Ribs of Beef*
*Spring Chicken, Sage Dressing*
*Lamb, Mint Sauce*

*Mayonnaise of Chicken*
*Mayonnaise of Lobster*
*Tomatoes    Lettuce    Cucumbers*

*Cold Beef    Ham    Tongue    Chicken*

*New Potatoes    Mashed Potatoes    New Beets*
*String Beans    Green Corn    Stewed Tomatoes*

*Lemon Custard Pudding    Whortleberry Pie    Orange Meringue Pie*
*Plum Cake    Jelly Cake    Madeira Cake*
*Vanilla Ice Cream    Neapolitan Ice Cream*
*Watermelon    Apples    Bananas    Grapes*
*Cheese    Nuts and Raisins*
*Café Noir*

### Stockton Hotel Cape May

### Menu

Oysters on Shell

| Clam Chowder à l'Americaine | | Consomme Italian Paste |
| Varies | Escalope of Lobster | Varies |
| Boiled Sea Bass, Hollandaise | | Baked Filet of Sole au Vin Blanc |

Pommes de Terre, Chateau

| Beef Braise Flamande | | Ham, Currant Jelly Sauce |

Sirloin of Beef, Napolitaine

Veal Pie, Vermont Style

Stuffed Tomatoes, à la Creole

Macaroni Milanaise

Claret Punch

| Ribs of Beef | | Spring Chicken, Sage Dressing |

Lamb, Mint Sauce

| Mayonaise of Chicken | | Mayonaise of Lobster |
| Tomatoes | Lettuce | Cucumbers |

| Cold Beef | Ham | Tongue | Chicken |

| New Potatoes | | | New Beets |
| String Beans | | Green Corn | |

Mashed Potatoes

Stewed Tomatoes

Lemon Custard Pudding

| Whortleberry Pie | | Orange Meringue Pie |
| Plum Cake | Jelly Cake | Madeira Cake |
| Vanilla Ice Cream | | Neapolitan Ice Cream |
| Watermelon | Apples | Bananas | Grapes |
| Cheese | | Nuts and Raisins |

Café Noir

Children occupying seats at first table will be charged full price.

**FRIDAY, AUGUST 7, 1885.**

Menu from the Stockton Hotel dated August 7, 1885—still mainly French fare, but with a little bit of Italian sneaking in. *Richard Gibbs.*

While this menu shows that the multicourse meals of the Victorian era were still going strong in 1885, we can also see more dishes that were not overly French in preparation. There appears to be some Italian influence starting to seep into the food preparation, such as the use of Italian paste, as well as the dish macaroni Milanaise, a French take on pasta and cheese with meat or truffles thrown in for good measure.

There is also considerably less lamb on this menu than on previous ones. Lamb would continue to be featured less and less as other meat sources became more prevalent on American restaurant menus. Veal pie, Vermont style, was more well known in the French Canadian province of Quebec as "tortiere," which could be filled with pork or beef.

How about some whortleberry pie for dessert? For those not familiar with the whortleberry, it is an English term for the bilberry, which is related to the blueberry but not quite the same. Bilberries are darker in color and tend to be softer and sweeter.

## Recipe: Clam Chowder

In 1894, the Cape May Baptist Church published the *Cape May Cook Book* with recipes from the congregation. This recipe was submitted by Mary Leaming:

*Fifty clams chopped fine, one-half pound broken milk crackers, one-half pound of salt pork sliced, fried brown, and cut in small pieces, one dozen small white onions sliced, two large potatoes cut in dice. Put in the kettle, in the order named in layers; when you come to the potatoes begin again with the clams, and so on, with small bits of butter over each layer. Pour the liquor over this and let come to a boil, then add three pints of hot milk (not boiled). Boil three hours.*

## End Story: Edward W. Dale, Annie Knight and the Meals She Ordered

Restaurateur, caterer and hotel owner Edward W. Dale came from Philadelphia to Cape May in the 1890s and spent many years helping to feed the hungry tourists and local residents. Being African American, Dale's

main clientele included the people of his race. But his catering prowess would extend to all areas around Cape May.

We know this from a historical gold mine in the form of Mr. Dale's ledger, found at the Cape May County Clerk's office.[23] Within the century-old pages are orders from clients during the years from 1897 to 1901. The Cape May Board of Trade ordered chicken and lobster salad on March 31, 1898. A case of beer was once sent to the South Jersey Rail Road Company. And the West Jersey Railroad Company had a monthly dinner catered by Dale in 1897 and 1898.

But the most intriguing narrative that comes from this ledger are the orders placed by one Annie Knight, the daughter of E.C. Knight, who would one day own Congress Hall after her father passed away. From November 11, 1897, to June 30, 1901, Knight had meals catered by Dale every day, with very few exceptions.

By and large, Annie Knight was a meat-and-potatoes kind of woman. Sirloin steak and Hamburg steak with French fries, French fried sweet potatoes or Lyonnaise potatoes (sliced and pan-fried with onions and butter) were regularly part of her orders. Her vegetable accompaniments were also simple: peas, asparagus and tomato salad. She was clearly a fan of the local oysters and would often order either a dozen on the half shell or fried.

The meals Annie Knight ordered also show some of the popular brands and trends of the day. She would frequently have lemonade made with Appolinaris sparkling mineral water. Although she did not order alcohol on a regular basis, she would on occasion indulge with a pint of Bass Ale, a bottle of Rochester beer (a very popular regional brand of that period) or even a quart of claret from California. Another occasional indulgence was a bottle of Moet & Chandon.

When entertaining guests, Dale rose to the occasion. Whether it was fried oysters, lobster Newberg and broiled chicken for a wonderful dinner or a simple order of "hot cakes for 5" for breakfast, Knight must have approved, for there was never any appreciable break in the orders placed.

Even on Christmas, E.W. Dale delivered. The meal ordered for December 25, 1898, was turkey with chestnut filling, asparagus, spinach, mashed potatoes, crab salad, terrapin and mince pie. A quart of St. Julien wine was included to finish the meal.

Sadly, no additional ledgers exist from E.W. Dale, so we do not know if Annie Knight continued to order from him. We also don't get from the one ledger what the relationship was between these two people. Both were not from Cape May yet would make themselves very much a part of Cape May.

# Chapter 4
# AMERICAN GLORY

As Cape May headed into the twentieth century, it was no longer the only game in town as far as beach resorts went in southern New Jersey. Atlantic City had become the showplace of the nation, while even in its own neighborhood places such as Wildwood and Ocean City were gaining followings.

## THE HOTEL CAPE MAY

*A noted chef has assumed charge, and throughout the year the most fastidious epicure will be able to find dishes to his fancy.*
—Cape May Star and Wave, *April 4, 1908*

The promise of a "New Cape May" was the driving force behind the building of a grand new hotel. A group of investors from Pittsburgh, headed by steel magnate William Flynn and real estate entrepreneur Peter Shields, bought four thousand acres of land in East Cape May.[1] Their ambitious plans included dredging and filling in marshland to build an estimated one hundred cottages. The plan also included the building of a grand hotel for the modern age.

When it opened in 1908, the Hotel Cape May was truly a marvel, complete with columns of marble and a glass dome that met the guests in

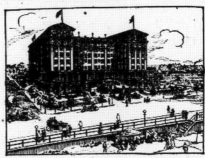

THE NEW MILLION DOLLAR HOTEL CAPE MAY

CAPE MAY CITY, N. J.

Opens April Eleventh and Will Remain Open Entire Year.

Finest Hotel on the Jersey Coast.

90 minutes from Philadelphia via Pennsylvania or Reading Railroad.

350 Bedrooms, 150 Bathrooms, with hot and cold fresh and sea water. Long Distance Telephone in every room. Four Standard Plunger Elevators. Perfect drainage. Absolutely pure water. Five mile Ocean Boulevard. Five mile boardwalk. Finest Bathing Beach in the world. Golf Club privileges. Yachting and Fishing in new 700-acre Harbor. Tennis, Billiards and Bowling. Orchestra. American and European plans. For Booklet, Rates, etc., address

JOHN P. DOYLE, Manager,
Cape May City, N. J.

Rates: American Plan, $4.00 per day upwards. European Plan, $2.00 per day upwards.

FOR EASTER WEEK RESERVATIONS CAN BE MADE FOR AS SHORT A TIME AS ONE DAY.

*Right*: Advertisement for the opening of the Hotel Cape May in April 1908. The hope of a New Cape May was riding on its success. *Library of Congress.*

*Below*: A postcard view of Hotel Cape May's dining room as it would have appeared to those who came to stay in its early days. *Liz Pongia.*

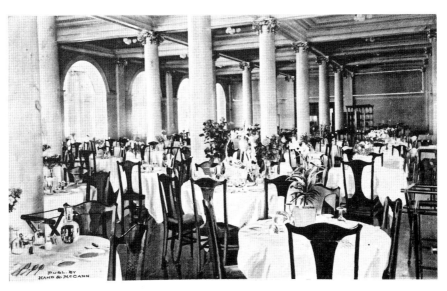

the expansive lobby. On its opening day of April 11, it was estimated that nine hundred people dined in the main dining room and the café.[2] People had traveled from all over the eastern seaboard to be a part of the grand opening that Easter weekend.

But despite the early success, the hotel would be closed by October of that year for improvements. The hotel had opened two years later than scheduled, and the overall building costs, which were originally estimated to be $500,000, had gone over $1 million.

More troubles were ahead, as the Cape May Real Estate Company, run by Flynn and Shields, would teeter on collapse. Shields eventually left the company, and the promise of a New Cape May seemed to be all but finished.

## Recipe: Fillet Mignon a la Cape May

Although Cape May is not usually associated with steak, Hotel Cape May's chef de cuisine, John Pfaff, provided his special take on preparing filet mignon. This recipe was part of a series of cookbooks that was produced in the 1910s that included top chefs from the United States, Canada and Europe. This recipe appeared in the book entitled *Roasts and Entrees of the World Famous Chefs*:

> *Cut four round fillets weighing about a half pound each from a nice tenderloin of beef, saute rare; put the fillet mignons on four round pieces of toast, place one mushroom on top of each fillet mignon, one round slice of red sweet pepper on top of mushroom and one round slice of truffle on top of red pepper; put six or eight asparagus tips around the toast, cover with a glass cover and put in oven for two or three minutes. Serve with a little Madeira sauce.*

## Bill of Fare: Windsor Hotel, July 25, 1920

*Cape May Salts on the Half Shell*
*Little Neck Clams*

# Salt Oysters, Beach Plums & Cabernet Franc

*Sweet Gherkins     India Relish     Cucumber Pickles     Olives*
*Currant Jelly     Quince Jelly*
*Mustard Pickle*

*Mock Turtle Soup, au Sherry*
*Chicken Consomme, Printaniere*

*Broiled Fresh Kingfish with Anchover Butter*
*Potatoes Parisienne*

*Roasted Long Island Duckling, Oyster Filling, Brown Gravy*
*Boiled Young Jersey Chicken, Supreme*
*Roast Ribs of Prime Jersey Beef with Essence*
*Baked Smithfield Ham, au Madeira*

*Fresh Peach Fritters*
*Lemon Sorbet*

*New Stringless Beans     Boiled Southern Rice     New June Peas*
*Mashed White Potatoes     Boiled Potatoes, Parsley Sauce*
*Silver Skin Onions, en Crème*

*Lettuce and Tomato Salad, a la Mayonnaise*
*Toasted Crackers     Cream Cheese*

*Fresh Apple Pie     Pound Cake     Cocoanut Custard Pie*
*Banana Ice Cream     Frozen Cherry Custard*
*Windsor Cream Slices*

*Café Noir*

By 1920, dining out had changed from its more French and opulent days in the nineteenth century. You don't need a French-to-English dictionary to understand the menu. There is also a feeling that the items being presented are more American than the previous bills of fare presented in this book. The oysters are now Cape May Salts, the chicken is Jersey chicken and the beef is Jersey beef. There's an attempt being made to connect to the surroundings—less pretense and more down to earth.

Image of a local market on Washington and Union Streets in 1917. *Cape May County Historical Society.*

# RUMRUNNERS AND BEER BARONS: THE PROHIBITION ERA

*After a chase from five miles off the Delaware Capes last Friday the Coast Guard patrol boats caused the crew of three men on the rum runner K-1414 an open craft to run her ashore at the end of Sunset Boulevard. The men leaped ashore and disappeared, but the guards captured the boat and 126 barrels of choice liquor.*
—Cape May Star and Wave, *March 23, 1933*

When the Eighteenth Amendment was ratified in 1920 and Prohibition became the law of the land, the alcohol did not stop coming to New Jersey. In fact, it continued to flow like water (and *on* the water as well). The inlets and creeks along the Jersey Shore provided ample opportunities for rumrunners to land their boats without being caught by the authorities. And Cape May would see its own share of intrigue under the cover of darkness or a heavy fog.

During the 1920s and early 1930s, there were many tales of intrigue and conflict between the rumrunners and the authorities. There were stories of Cape May residents being suddenly awakened by the sounds of machine gun fire as the Coast Guard attempted to stop a speedboat from making land with its haul of illegal alcohol.

Local restaurants and hotels got themselves into some trouble with the law during this period. In April 1931, a major raid throughout the Jersey Shore included locations in Cape May. The C-View Inn was caught with beer and home brew, while the Italian Grocery Store on Broad Street was found in possession of wine and moonshine.[3]

When the Cullen-Harrison Act was passed by President Roosevelt in 1933, allowing the production and sale of beer with 3.2 percent alcohol or less, the city council of Cape May granted licenses to eight local businesses. These eight included Henri's, C-View Inn, Kahn's Restaurant and the Merion Inn as well as the Mayflower Casino and Romeo Macciocchi's restaurant.[4]

Drinking came back in full force with the ratification of the Twenty-first Amendment in December 1933. By the following June, Congress Hall had opened Cape May's first cocktail bar.

## Cape May's Romeo

The aforementioned Romeo Macciocchi, who listed himself as working in construction, also had a career in the food business in Cape May. He started as an importer of Italian food items such as olive oil, cheese and pasta in the 1920s. By the 1930s, he had his own restaurant on Lafayette Street called Romeo's, where "Real Italian Food" was served. He had a beer garden next to his restaurant. By the 1940s, his restaurant had changed to the Roma Bar, where "Real Italian Spaghetti" could be had.

In 1933, Romeo's personal life would become headlines in the local papers. He had a nephew named John who lived with him on Lafayette Street. A disagreement between John and Romeo led to an altercation; John was charged with assault and battery. Instead of facing his charges, John ran away and caught a fishing boat headed for Boston.[5]

Although Romeo Macciocchi has long since left this world, in some ways his spirit is still alive in places like Godmothers Restaurant. Opened in 1983 in a building erected in 1924, Godmothers helped to usher in a new era in

Advertisement in the *Cape May Star and Wave* in 1933 for Romeo's restaurant on Lafayette Street. The beer garden was now able to sell beer with the passing of the Cullen-Harrison Act.

Italian American cuisine in Cape May. "Real Italian Spaghetti" in Romeo's day is now called Spaghetti Pomodoro on Godmothers' menu, but Romeo would probably still approve.

## CAPE MAY DURING THE WORLD WARS

World Wars I and II were exciting times in Cape May. In 1917, the United States Navy established a base near Schellenger's Landing for training purposes and support. The Hotel Cape May, which was not being used, was

The Congress Hall owners and staff, seen in the 1920s. After fifteen years, it was closed over a squabble with the local government. Anne Knight later opened up the great hotel for visitors again. *Congress Hall.*

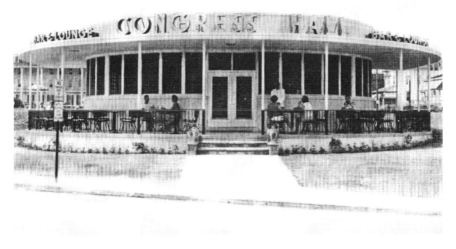

The circular cocktail bar built by Congress Hall in the 1950s. It is now Bill's Pancake House. *Congress Hall.*

taken over by the military and served as a hospital. These locations served similar purposes during World War II as well.

Having military personnel helped to give the local economy a boost, but it would be short-lived. When Word War II ended, the naval base was handed over to the Coast Guard, and the Hotel Cape May went back to the city, without an owner.

Congress Hall was not available during World War I. Owner Annie Knight had been in a squabble with the town over the road conditions and

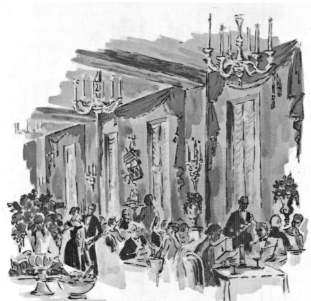

FIFE and DRUM DINING ROOM overlooks the pool and ocean. Its delicious meals are complimented by prompt, cordial service.

*Above*: The view from inside the cocktail bar in the front of Congress Hall. *Congress Hall.*

*Left*: During the 1950s and 1960s, Congress Hall had gone to a strong American theme in its décor. Here is a look at the Fife and Drum Room in a brochure from the 1950s. *Congress Hall.*

who should pay for their improvements, and in 1904, she closed the hotel. The issue was finally resolved in 1920, and Knight reopened Congress Hall for visitors once again.

During World War II, under the care of new owner Joe Uhler (a Philadelphia hotelier), Congress Hall had successful summer seasons—thanks mainly to the naval personnel stationed in Cape May. When the navy left, Uhler had to try new ideas to keep up the same level of success. He built a modern circular bar in the 1950s on the hotel grounds. An advertising campaign was created based on mint julep, harkening back to the times when juleps and cigars were the perfume of the day.

By 1958, ownership of Congress Hall had changed once again, and a new patriotic theme was given to the place. Patrons could now dine in the Fife and Drum Room or the Yankee Clipper Grille. Mixed drinks were available at the Yankee Doodle Lounge, complete with red and blue walls and American Revolution murals.

## Gone but Not Forgotten: The Eateries and Candy Shops that Are No More

There is a very divergent opinion of Cape May of the early and mid-twentieth century. Some will argue that it was a shore town on the decline, while others loved the relative calm and quiet of the summer seasons in comparison to the wild and rambunctious shore towns farther north. But everyone agrees that there are places that they wished were still around today. And while it would take too long to mention every single one, this is an attempt to bring some attention to a handful that hold a special place in the hearts of those who love Cape May.

Arnold's Hotel and Sunny Hall Café were two popular places for food and drink. There's a link between these two establishments in Charles Arnold. Arnold's father was a German-born liquor dealer who moved his family from Pennsylvania to Cape May. Charles worked as a hotel clerk before opening his own place.

Arnold's Café was opposite the Iron Pier along Beach Avenue. It was a place for steaks, seafood and beer. A meal could run you a whole fifty cents. Before Prohibition, it was a place where "good dinners and 'good times' were to be had," as described by historian Alfred M. Heston.[6]

By 1921, Arnold had left behind his Cape May hotel and restaurant and opened a new place outside the shore town called Sunny Hall Café. Here

GALA OPENING

# SUNNY HALL CAFE

(*On the Old Shore Road 2 Miles for Cape May*)

## Sat. Eve., July 1st, 1933

*with*

### Sylvan Herman and his Broadway Brevities

## 2 Shows Nightly

Excellent Cusine :: Seafood our Specialty

MAY WE ..AVE THE PLEASURE OF SERVING YOU
IN THE COOLEST SPOT, WHERE
YOUR PATRONAGE IS WELCOME

### NO COVER CHARGE AT ANY TIME

Advertisement for the reopening of Sunny Hall Café in the *Cape May Star and Wave*. It promised great food and lively entertainment.

he brought his specialties of "Chicken Waffle dinners, Seafoods, sandwiches and other attractive dishes which made the Arnold Hotel famous for years."[7] But Arnold passed away during the 1920s, leaving his wife to tend the Sunny Hall Café for a time. A new Sunny Hall restaurant attempted to open in 1933, offering its own dance orchestra, but that version of the Sunny Hall Café did not last very long.

The restaurant that would take the place of Arnold's was Henri's, managed by Henri Borbach. Specializing in seafood, Henri's was a fixture in Cape May until the 1960s. Henri's was one of the eight places in Cape May that were granted licenses to start selling beer in 1933, which is interesting considering that in 1930, Henri Borbach was indicted for having slot machines in his place of business (most likely to appease the local beer barons in order to have liquor available during Prohibition).

Along the boardwalk, places such as the White House Tea Room and Roth's Candy Land were beloved. D.J. Walters, also known as "Uncle Dave,"

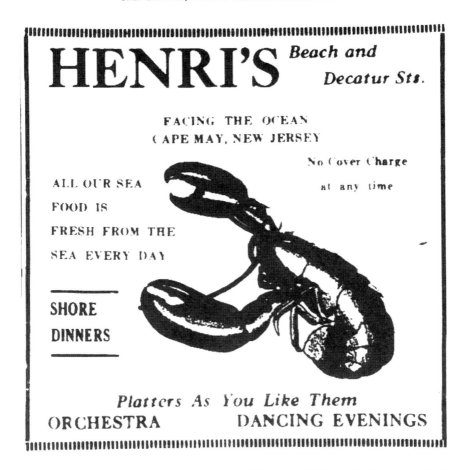

# HENRI'S Beach and Decatur Sts.

FACING THE OCEAN
CAPE MAY, NEW JERSEY

No Cover Charge
at any time

ALL OUR SEA FOOD IS FRESH FROM THE SEA EVERY DAY

SHORE DINNERS

Platters As You Like Them
ORCHESTRA        DANCING EVENINGS

Henri's advertisement in the *Cape May Star and Wave* from 1933 says it all: fresh seafood and platters as you like them! Henri's occupied the corner of Beach and Decatur Streets for four decades.

sold ice cream, sodas, hot dogs and sandwiches from his White House Tea Room for many years. The hurricane of 1944 caused major damage to the tearoom. And right by the Iron Pier stood Roth's Candy Land, owned by Fred W. Roth. Roth's Candy Land touted its saltwater taffy and would eventually have multiple locations, including one on Washington Street.

Although saltwater taffy was more of an Atlantic City standard, Cape May had its share of confectioners making their own. The most beloved of them all was Petroff's Homemade Candies, under the ownership of Max Petroff. An immigrant from Austria who came to Philadelphia and learned his candy-making skills as an apprentice, he opened his candy store on the boardwalk in 1917. A fire on the boardwalk the following

year forced Max and his wife, Leah, to move their business to a location along Beach Drive.

Passersby could watch through the window as the taffy was being stretched. The taffy-making machine was a creation of Petroff himself and would still be in use when his daughter and son-in-law, Claire and Jack Berlin, took over the business in 1970 and continued to make homemade candy with the Petroff name into the 1990s.[8]

As beloved as he was, Max Petroff did have one moment where he ran afoul of the local authorities. When beer was first allowed to be served again in Cape May in 1933, it came with a strict enforcement against those who were not licensed to sell beer. And the first person to be arrested under this new law was Max Petroff. Having tried to apply for a beer license but refused, Petroff took matters into his own hands. He was caught offering free beer to those buying one of his pretzels. His jail time was short-lived, however, as he was soon released due to lack of evidence.[9]

William Essen's bakery was sold in 1914 to Carl and Margaret Kokes. Margaret was Essen's niece, and Kokes had come to this country from Hungary at the beginning of the twentieth century. Kokes would become a staple of Cape May for many decades.

Kokes was most beloved for its elephant ears (palmier) pastries. Author and Cape May historian Ben Miller remembered Kokes and those elephant ears fondly: "My dad and I spent many, many morning in there, ordering elephant ears and then eating them as we walked around town. We were always there early, so we'd have the opportunity to sort of watch the town wake up each morning. Store owners would come out and clean outside their business, street sweepers dominated the roads, and big trucks would make their deliveries to local restaurants. There was something unique and comforting about a Kokes elephant ear and that buttery cinnamon flavor was really something."[10]

Although Kokes is no longer in existence, the legacy of Kokes lives on in the person of Michel Gras. Gras was working as a baker at Kokes at the time it closed. He now makes his pastries at the Little Store Market, where fresh baguettes are baked every day. Who knows, you just might find elephant ears there as well.

It seems to be virtually impossible to tell a story about food in New Jersey without mentioning pork roll. And Cape May is no exception to this rule. The Taylor Pork Roll shop opened in 1949 as part of a building that also housed a candy store. When the candy store closed after only a few years, Taylor Pork Roll took over the entire building. And for forty-three years,

The children would wholeheartedly agree with this idea from a 1930 advert of ice cream as the perfect food. Kokes' Bakery delighted children and their parents for many summers.

until the business closed for good in 1992, it served up sandwiches and birch beer from nine o'clock in the morning until eleven o'clock at night from Memorial Day through Labor Day.

Running the store day in and day out was the job of Ann Dash, along with her sister, Fay, and other family members. During the summer months, their place would be packed, with lines going out the door. The favorite of the summertime customers? A pork roll with cheese, of course.[11]

Ann Dash and crew taking a brief moment from their work at Taylor Pork Roll for a picture in 1961. Those wrapped pork rolls hanging from above were filled with sawdust. *Steven and Lenore Dash and Carrie Warwick.*

A group of sailors enjoying a little time off and having some fun for the camera at Taylor Pork Roll. *Steven and Lenore Dash and Carrie Warwick.*

In 2015, a distinctly blue restaurant appeared on the scene by the name of Fins. As bright and gleaming as it looked, the building that it occupied had been the home of two beloved restaurants from days gone by. The Tarpon Bar was beloved by the locals for its sandwiches, be it a ham and cheese or a liverwurst with onions. Milton and Violet Blume owned the Tarpon for a quarter of a century, and those who remember think that maybe it was the love that the owners put into their food that made it taste so good.

After the Tarpon Bar came the Pilot House, which had its own run of forty years as a family-friendly casual dining place with a nautical theme. As a nod to the Pilot House, Fins made sure to have plenty of fish tanks in the new place. The Pilot House was known for its fish tanks.

## End Story: The Reverend Tasted a Beach Plum

*The bushes entwine you into the sand, the sea, and the sky; and the ripe, rich purple adds a befitting royalty to the great outdoors.*
*—from a sermon by Reverend Carl McIntire*

Reverend Carl McIntire, who would become a prominent figure in the history of Cape May from the 1960s to the 1990s, had an epiphany, and it came in little jars. One Christmas, he was given some jars of beach plum jelly by a member of his church in Collingswood.[12] According to Reverend McIntire, "I had never heard of it nor seen it before, but the first piece of toast with that jelly on it told me that it was different, simply marvelous. We began to ask questions about this jelly which had such a tang to it."

When McIntire inquired about the beach plums, the woman from the congregation informed him that she traveled to Cape May County to pick the plums. So he and his wife decided to make the trip down to pick some of these beach plums. They didn't even know what beach plum bushes looked like, but after observing others, they learned how to find these newly cherished fruits. Thus began an annual pilgrimage to Cape May, and Reverend McIntire himself would make his own batches of beach plum jelly.

McIntire's love for the beach plum became the inspiration for naming the circular restaurant on the grounds of Congress Hall that he became the owner of when he bought the hotel. He renamed the restaurant Beach Plum Restaurant in 1968.

At the newly named restaurant, a grandson of Reverend McIntire worked as a waiter. His name was Curtis Bashaw, and at age fifteen, he had his first job and loved it. He also loved the grand Sunday buffets served at the Christian Admiral Hotel, the former Hotel Cape May that was also purchased by Reverend McIntire. By age twenty-two, Bashaw had become hotel manager of Congress Hall, but even greater adventures were ahead for him in the coming years.

## Chapter 5
# The Restaurant Capital of New Jersey

In 1996, Fran Schumer of the *New York Times* used this very phrase to describe the flourishing dining scene in Cape May, which by that time had gotten its culinary groove back. The journey that Cape May took from a quiet, nearly forgotten shore town of the past to a relevant food destination took time, patience and a series of events that would propel Cape May back into the national limelight.

## The Storm of 1962

A nor'easter caught Cape May and much of the Jersey Shore by surprise in March 1962, and it turned into a three-day siege of rain, flooding and high winds. Cape May suffered a significant amount of damage. The boardwalk had been chewed up and spit out, with planks being used as projectiles by the strong winds. Windows of the stores across the street were smashed in by the force of the planks.

When the winds died down and the damage was surveyed, it was determined that this had been the worst storm to have hit Cape May. The convention hall had been damaged beyond repair. Hotels all along Beach Avenue had suffered some kind of damage. Estimates of the destruction came to about $3 million. Once again, Cape May was faced with a major rebuilding project that would change its course.

In the aftermath, Cape May would no longer have a boardwalk. It was determined that a more secure concrete sea wall would be built to protect its buildings along Beach Avenue. But the storm also exposed a bigger issue with Cape May: this community was on the decline and needed to figure out where it was going. Shore communities such as Wildwood and Ocean City to the north were attracting a younger, more family-oriented audience. Cape May seemed lost in the past.

The resurgence of Cape May was the result of three forces, moving on their own schedules and working together as three legs work to hold up a stool.

## Cape May Goes Forward by Looking Back

The concept of embracing Cape May's past as a way to propel its future was not a new idea. The concept of a Victorian Village, similar to what had been done in Williamsburg, Virginia, had been proposed in the early 1960s in the aftermath of the 1962 storm. But this project would have only preserved a small portion of the Victorian architecture enjoyed today. It would take the work of Carolyn Pitts, who was originally sent by the National Park Service to survey the damage of the 1962 storm, to set forces in motion.

With the backing of the Historic American Buildings Survey, Pitts worked to obtain grants to have the entire town surveyed. She could see that Cape May was filled with architectural treasures. And without the blessing of the town leaders, she had Cape May placed in the National Register of Historic Places.[1] But her boldest move was yet to come. Through her work, the entire city would become designated as a National Historic Landmark, a designation that few towns in the country had earned. By 1976, the leadership of Cape May had changed and now embraced this path. The great Victorian structures would be preserved for all to see—a living, breathing museum of American architecture.

As part of these changes, an organization called Mid-Atlantic Center for the Arts & Humanities (MAC for short) took up residence in the Emlen Phyisck Estate and worked to promote the efforts of Cape May's preservation advocates. Today, MAC has helped make Cape May a year-round attraction with historical tours, food and wine events and other specials throughout the year.

# THE RESTAURANT ANCHORS OF CAPE MAY

The second leg of this stool had to do with the resurgence of Cape May's restaurant scene. How does a town become known for its restaurants? While we may think that a great food town is always showing off the next new shiny thing in cuisine concepts, there is a need for restaurant anchors, the places that stick around long enough for word of mouth to make its way around and keep bringing the diners back for more. During a stretch from the mid-

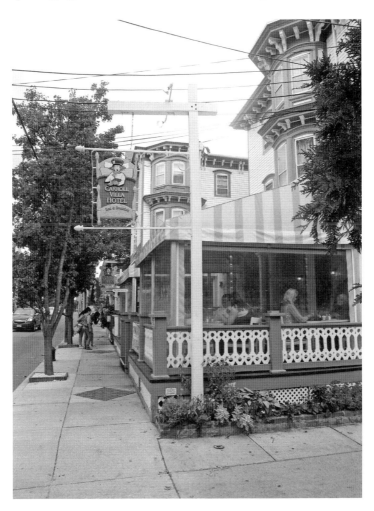

In all seasons, people will find their way to Jackson Street and the yellow-and-white awnings of the Mad Batter at the Carroll Villa Hotel for a bite.

1970s to the late 1980s, a group of restaurants emerged that has become the anchor of Cape May's vibrant dining scene.

When did Cape May's restaurant resurgence begin? One could make an argument that today's vibrant restaurant scene began over a poker game. Although urban legend says that art gallery owner Harry Kulkowitz won the Carroll Villa in a poker game, this is not true. But it was while playing poker with the then owner of the hotel that Kulkowitz became interested in owning the hotel. His intrigue became reality when he became owner of the Carroll Villa and opened for business in 1976. As part of the hotel, he also established a restaurant that he called the Mad Batter. Harry's restaurant got a positive review in the *Philadelphia Inquirer*, and suddenly the Mad Batter became a known quantity and a food destination.

Along the way, Harry brought his son, Mark, aboard to manage the hotel and restaurant. One of the employees at the hotel, Pam Huber, became Mark's wife and a key component in running the business. And now their three children have become a part of the running of the Carroll Villa and the Mad Batter as well.[2]

Now, about those distinctive awnings. Anybody who knows Cape May knows that the Mad Batter is easy to spot on Jackson Street by its bright yellow-and-white striped awnings. It turns out that having done research on the history of the Carroll Villa, Harry Kulkowitz discovered that these colors were historically accurate.

## Recipe: Mad Batter Clam Chowder

*This clam chowder has appeared on the Mad Batter's menu since the beginning, so it has stood the test of time. With this relatively short list of ingredients, the home cook can re-create a little taste of what's been going on under the bright yellow-and-white awnings all these years.*

*Ingredients*
½ *pound bacon, chopped*
1 *onion, diced*
1 *quart heavy cream*
1 *quart half and half*
*pinch saffron*
*salt and pepper*
3 *cups chopped clams with juice*

*Directions*

*In large pot, render bacon to crispy. Add onions and continue to cook until soft. Drain bacon grease. Add cream, half and half, saffron, salt and pepper to taste and clam juice. Bring to soft boil. Chill well if not using immediately. Serves four.*

But one restaurant does not a restaurant scene make. Then along came Toby and Rona Craig, schoolteachers from Delaware. In 1978, they purchased the Washington Inn, a manor house built in 1840 that had operated as an inn since the 1940s. Knowing nothing about running a restaurant, the Craigs rolled up their sleeves and turned the Washington Inn into one of the most consistently well-regarded restaurants in Cape May.

The Washington Inn is very much a family business. Their son, Michael, learned the wine trade through working at a hotel in Switzerland that had an extensive wine cellar.[3] He brought that knowledge back with him, and the Washington Inn has over the years become a destination for wine lovers. The wine cellar has held as many as ten thousand wines. The Craigs also purchased Cape May Winery in 2002 and regularly hold wine education classes that use both locations.

There are five different dining areas that are part of the Washington Inn, as well as a cozy fireplace that is a draw during the colder months. And as for weddings, the Washington Inn has become one of the most sought-after locations in the state.

Meanwhile, back on Jackson Street, farther down from the Mad Batter, a small and quiet dining revolution was taking place. It was 1980, long before the phrase "farm to fork" became a part of the modern food lexicon. But that was what Louisa Hull and Doug Dietsch were creating in their small eatery called Louisa's Café. From its beginning, the focus of this restaurant has always been to use local ingredients, whether it is seafood from the ocean or bay or produce from local farms.

While the food preparation has always been thoughtful, the restaurant itself has been more whimsical in its look. The colors are bright, and the artwork around the space is childlike in its simplicity. Even though the building where it resides dates back to the 1830s, Louisa's has never tried to fit within its Victorian surroundings. And yet it has always seemed quite comfortable.

We move ahead to 2014, when Doug and Louisa decided to hand the reins over to Will Riccio, who at one time was a dishwasher at Louisa's. Riccio is a Cape May man—his father clammed here—who decided to

Make your way through the tropical flora that flows out onto Bank Street and come inside to a meal from a modern Cape May classic.

come back to his hometown to be a part of the community. But don't think the original owners won't be keeping an eye out to see how things are going. Louisa Hull is right next door, running her new venture, a boutique-like confectionery called the Chocolate Bar.

Of all the streets one can walk along in Cape May, Bank Street is not high on the list. It is almost an afterthought, sneaking off Lafayette Street right before you make the left turn into the heart of town. But if you decide to make the walk down Bank Street, you will be met with the wondrous sight of

tropical flowers flowing out onto the sidewalk. This is 410 Bank Street saying hello to all who make their way.

Before 410 Bank Street opened its doors in 1984, the notion of a chef of Asian descent preparing dishes with a New Orleans/Caribbean flair would have seemed quite, well, foreign to the locals on Cape Island. But owners Steven and Janet Miller, who worked in the motion picture industry as producers, knew a thing or two about creating a great story. They brought on board Chef Henry Sing Chen, a Chinese-born, French-trained chef

The Virginia Hotel, the first major restoration project of Curtis Bashaw. Inside is the famous Ebbitt Room restaurant, one of the great showpieces of Cape May.

whom Janet met while taking cooking classes in Manhattan,[4] and they have never looked back. Year after year, 410 Bank Street finds its name in lists of best restaurants in Cape May, New Jersey and the country.

The Virginia Hotel, which was built after the Fire of 1878 and had been a rooming house as late as the 1950s, fell into severe disrepair. In 1988, the building was purchased by Curtis Bashaw and was reopened in June 1989. The cost of the restoration, $3 million, was the largest of its kind in Cape May. But what Bashaw and his company did was to turn the Virginia into a beautiful boutique hotel.

The crown jewel of the renovation was the restaurant known as the Ebbitt Room. The Ebbitt Room quickly became regarded as one of the best places to dine in town. The restaurant started as a more formal dining experience, but in recent years, it has loosened up to adhere to the needs of the current dining public, which wants to be more casual. Another well-known feature of the Ebbitt Room is the bar area, where the mixologists have been experimenting with farm-to-glass cocktails.

## The Bed-and-Breakfast Salvation

The birth and explosion of the bed-and-breakfast in Cape May was the third leg of the stool, and what a leg it has become. It is hard to even imagine Cape May today without seeing wonderfully restored Victorian homes that have been turned into gorgeous inns, and yet this whole part of the hospitality industry didn't even exist until 1971. That is the year that Tom and Sue Carroll opened the original Mainstay Inn on Jackson Street. Eventually, they moved to Columbia Avenue and, with $100,000 in restorations, opened a new Mainstay Inn, where it still entertains guests to this day.

The Carrolls enjoyed some fame on the national front when they appeared on the cover of *Americana* magazine in 1979. That story launched the bed-and-breakfast boom in Cape May. Ten years after the *Americana* cover, there were sixty-five bed-and-breakfasts in the city. Cape May had become the biggest location for Victorian bed-and-breakfasts in the country.[5]

But as the name indicates, a bed-and-breakfast needs to focus just as much on the breakfast as it does on the bed. Just as much as the Mainstay Inn was known for its Victorian splendor, Sue Carroll also developed a reputation for the meals she prepared for breakfast and for afternoon tea (a tradition held at many of the bed-and-breakfasts in Cape May). Carroll eventually

published a cookbook of her cooking triumphs over the years entitled *Breakfast at Nine, Tea at Four*. Other bed-and-breakfasts followed suit.

The Angel of the Sea, one of the most recognizable bed-and-breakfasts in Cape May, has been entertaining guests for a quarter of a century. Built in the 1850s and then given a radical splitting in 1881 (the owner wanted the house moved to get a better view of the sea, the workers split the house in two to make it easier to move, they couldn't put the two parts back together…you know, the usual story), the Angel of the Sea has recently changed ownership. Theresa and Ron Stanton bought the iconic inn in 2015 and continue the traditions that have been established while adding a few touches of their own.

A cookbook by the Angel of the Sea was published back in 1994, and the Stantons continue to use recipes from it. But that doesn't stop them from preparing some of their own creations, such as a breakfast of sherry poached eggs (eggs poached in butter and sherry served over a toasted English muffin and topped with parmesan cheese and scallions), garnished with orange slices and strawberries and served with a side of applewood smoked bacon. The owners look to purchase their produce locally, as well as order hard-to-find cheeses and meats from Italy for their charcuterie as part of their evening wine and cheese selection.[6]

## End Story: A Dessert Requiem for a Falling Admiral

The promise of a New Cape May in the beginning of the twentieth century, headlined by the grand Hotel Cape May, never came to fruition. Cape May found its way, but it was not due to the success of this hotel. In fact, in order to save and bring back Congress Hall, the Christian Admiral (as the Hotel Cape May was then called) was demolished, and proceeds of the sale of land were used for the restoration of Congress Hall.

To honor this beautiful yet tragic building, Jeffrey Space, the pastry chef at the Washington Inn, created a special dessert in its honor. "The Admiral's Finish" was a sweet treat for the eyes and taste buds but bittersweet in its meaning. On February 29, 1996, the Christian Admiral came down, never able to live up to the expectations.

## Chapter 6
# OF BEACH PLUMS, LIMA BEANS AND THE FARMS OF CAPE MAY

The picture of mid-nineteenth-century Cape May that is usually presented is one of large opulent hotels along the shore with well-to-do sea bathers enjoying the thrill of the ocean waves. But right behind all of this were the many farms growing crops and raising livestock. And sometimes, those two worlds would meet.

A letter to the local paper from April 11, 1861, showed gratitude toward the local pound keeper for his efforts "to clear the streets of cattle and horse….The public have been annoyed long enough with such nuisances and ought to be rid of them."[1]

Cape May in the 1860s was, in many ways, still much like it had been in the late seventeenth century. Seven out of ten residents worked either on land as a farmer or laborer or on the sea as a fisherman or pilot—or did a little of both.[2] While the summer season filled the newspapers with the local gossip on the hotels and who was staying where, the other nine months or so were filled with articles for farmers on new techniques for growing crops, reports from the area farmers' club meetings and advertisements for fertilizer.

Further illustrating the interesting dichotomy between the great seaside resort and the local residents, an ordinance was passed in 1880 noting that swine had to be kept out of the Cape May city limits between May 1 and October 1. After all, you couldn't have the hogs mingling with the guests now, could you?

## STRAWBERRY FESTIVALS

Although the beach plum is the official fruit of Cape May County, it was the strawberry that would first be celebrated with festivals. In June, the prime time for ripe Jersey strawberries, local churches held strawberry festivals as a means to encourage community and to raise some money for the church.

Sometimes a church was able to enlist the services of one of the hotels to throw a big celebration. Congress Hall was the place for one such festival in 1867. The multiple-day festival was a combination of gayety and piety, as there was music and dancing (and strawberries) as well as hymns and ministers delivering their messages (and strawberries). How could one not have been enthralled by the following scene painted by these words: "Entering the brilliantly illuminated hall everything in harmony with all nature outside, seemed radiant with loveliness, and we were forcibly reminded by the munificent floral fragrance which greeted us, that the month of buds, blossoms, beauty and strawberries was upon us."[3]

If you happen to attend the strawberry festivals that take place in West Cape May or at the Gandy Farmstead in Upper Township, know that this has been a Cape May tradition for more than 150 years. The other thing to know is that freshly picked Jersey strawberries are truly a treat and a hint of the summer season to come.

# THE COUNTY FAIRS OF 1870 AND 1920

The county fair, a staple of the summertime throughout the counties of South Jersey today, was a new enterprise for Cape May County in 1870. The Cape May Agricultural Society decided on holding its first ever county fair in September of that year, after the heat and bustle of the summer season. The two-day affair was, by and large, seen as successful. Fifty years later, over a two-day period in September, the Cape May County Fair of 1920 also went off successfully, with numerous exhibits and special events to keep the fair attendees occupied.

Why mention these two fairs in particular? The 1870 fair, of course, was the one to start off the whole tradition. And the second helps to provide some perspective as to the changes of Cape May's agricultural landscape as it transitioned to the twentieth century. The fair of 1870 showed that

**1870.  ANNUAL FAIR.  1870.**

CAPE MAY COUNTY

**Agricultural Society.**

____Class,_____

____Division,_____ No._____

Deposited by_____

____Premium,_____

A registration card for the county fair thrown by the Cape May County Agricultural Society in 1870, its first attempt at a county fair. *Cape May County Historical Society.*

Cape May County still had a significant amount of livestock on surrounding farms. Entries of horses, cattle and sheep, in addition to chicken and hogs, were judged as part of the festivities. By 1920, we find only chickens and hogs (and rabbits) being judged. While wheat and oats were a hot topic of discussion for the judges in 1870, by 1920 there was only one entrant for wheat and none for oats.

In both fairs, there were a plethora of apple varieties. One exhibitor at the 1870 fair had no fewer then twenty-seven varieties of apples on display. The 1920 fair had not only the common varieties we would recognize today—like McIntosh, Stayman Winesap and Rome—but also ones that have been lost to the ages: Ben Davis, Reeve's Favorite and Turn-O-the-Lane, just to name a few.

A certain vegetable was up for display in 1920 that was not present in 1870, and it would be one that would be of significance for much of the twentieth century in Cape May County: the lima bean. And while the fair attendees admired the sewing machines in 1870, it was the flying machines that caught the attention of the 1920 crowd, with airplane demonstrations as part of the festivities.

The star of the 1870 fair? According to the local reports, it was the sweet potatoes, which caused the writer of the article to exclaim that "we cannot

forbear speaking of the mammoth proportions and superior qualities" of the sweet potatoes that were on display.[4] Maybe there was something to that Cape May Coffee after all!

Fruit was the focus of the 1920 fair, include the aforementioned apples. Pears, peaches, various berries and even a quince or two made appearances. Despite the failure of the sugar cane experiment during the 1880s, at least one farmer, D.B. Cresse of Cape May Court House, received a special prize for the cane he was able to grow. Another special prize went to Charles Howell of Dias Creek for his homegrown hops.

Special mention must be made of a farmer by the name of Doolittle and his cucumbers from the 1870 fair. His display was of the variety known as General Grant, named after a man known to be a lover of the cucumber. But it was the size of the cucumber, measured at just over five feet, that drew the most attention.

The strawberry festivals and farm fairs fell on the calendar right before and after the summer bathing season. In some way, these festivals seemed as if they belonged to the residents of Cape May and the surrounding county—not to the invading masses that sought the beaches and mint juleps. They said, in so many words, "These are for us."

## Sugar Cane on the Cape

The growing of sugar cane and sorghum had been attempted by area farmers, with varying degrees of success. Local reports of farmers growing sorghum saccgaratus, known as "Chinese sugar cane," during the 1850s gave some promise that sugar could be a potential crop.

By 1880, the United States was importing $300 million in sugar, and there was a push to grow and refine sugar domestically. To encourage state farmers to try their hand at producing sugar, the New Jersey state legislature authorized the payment of a bounty for enticement. This attracted the interest of Hildreth & Sons, a sugar refining company based in Philadelphia. It formed the Rio Grande Sugar Company in 1881 with almost two thousand acres of land purchased for the purpose of growing sugar cane and sugar beets.

At the height of its production success, the sugar refinery produced 367,000 pounds of sugar and eighty-seven thousand gallons of molasses during 1884. But in the following year, the bounties paid by the state were

stopped. The price of importing sugar had also dropped, reducing the perceived need for a domestic supply.

Although Harry Hughes, a local resident and part of the Rio Grande Sugar Company, built his own facility to continue experimenting with better extraction methods, the industry did not continue, and the whole venture was shut down in 1889.

## Nelson Z. Graves and the Cape May Farmstead

With the Hotel Cape May and the Cape May Real Estate Company in bankruptcy, in came a knight in shining armor. Nelson Z. Graves, a successful industrialist from Philadelphia who was a regular cottager in Cape May, took over both operations. In addition to these endeavors, Graves had started a dairy and poultry farm in Cold Spring called Cape May Farmstead.

The farm was five hundred acres in size and was home to eighty-five milking cows and eight thousand chickens and ducks.[5] One thousand eggs were laid on a daily basis. And the farm equipment was, according to the advertising, the latest in the industry. But it was the milk that received the greatest hyperbole. The milk produced by the cows at Cape May Farmstead was promoted as being of the highest quality, coming from the cleanliest of conditions, and the cream was "rich and unmodified."[6]

Cape May Farmstead also boasted that its products were being used by hotels in New York, Philadelphia and right in Cape May, including the Hotel Cape May. It is interesting to note that the concept of owning a hotel as well as the farm that supplies the hotel would be seen as such a novel idea a century later (more on that in a moment).

Regardless of the quality of the products produced at Cape May Farmstead, the financial strain on Nelson Z. Graves and all of his Cape May properties would become too much to handle. Graves had to file for bankruptcy himself, leaving the Hotel Cape May once again without an owner.

## The Farm Kids of World War II

With a shortage of manpower during World War II, area high school students enlisted themselves to local farmers to provide needed labor. The students

Beach plums growing on a bush near the shoreline. Aside from being edible, they also help with dune protection. *Joe Alvarez*.

A close-up of beach plum blossoms growing on tress. *Joe Alvarez*.

Beach plums are typically smaller than regular plums. This is a batch that has just been picked. *Joe Alvarez*.

Beach plums grow in a number of varieties. Some are golden in color, and the flavor of these types has been compared to champagne. *Joe Alvarez*.

Cape May Salt oysters from Atlantic Cape Fisheries, just after being harvested and cleaned. *Brian Harman.*

Oysters contained within the "rack and bag" system along the Delaware Bay. This also makes for a nice perch for birds. *Brian Harman.*

*Left*: A colorful display of squash and cucumber—just some of the produce available at the West Cape May Farmers' Market.

*Below*: At the Lima Bean Festival, it is the real deal: Fordhook limas that were grown at Rea's Farm.

Beach Plum Farm is not only a genuine working farm growing produce for hotels and restaurants, but it is also a great place for a stroll on a sunny day.

Just a few of the variety of breads baked in the clay oven at Enfin Farm on the way to Cape May Point.

Locally harvested clams ready to be eaten during a seafood festival. There's never a shortage of fresh seafood in Cape May.

Oysters on the half shell at the Lobster House. Sitting out on the deck and watching the boats go by is not a bad way to spend an afternoon.

Scallop boats at Fisherman's Wharf by the Lobster House, taking a rest after an early morning's work.

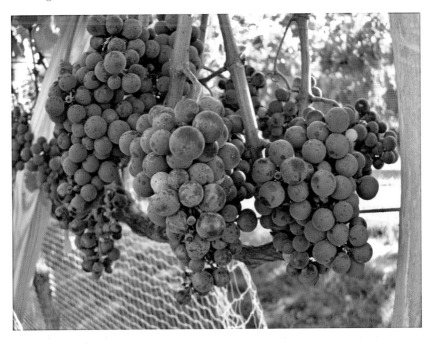

Wine grapes that will soon be ready for harvesting, located at Hawk Haven Winery in Rio Grande.

*Left*: Chef Lucas Manteca preparing a meal for that night's dinner crowd at the Red Store in Cape May Point.

*Below*: With this kind of patriotic paint job, this could only be called the Yankee Doodle Cocktail Lounge. From Congress Hall in the 1960s. *Congress Hall.*

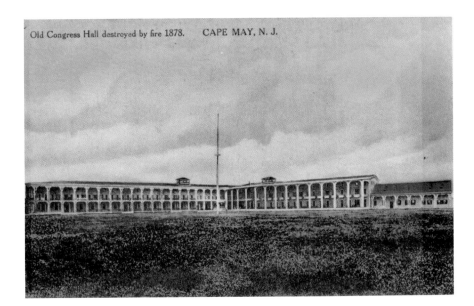

Old Congress Hall destroyed by fire 1878.   CAPE MAY, N. J.

*Above*: A colored postcard of Congress Hall, the version that existed right before the fire of 1878 burned it to the ground. *Congress Hall.*

*Right*: Her place may be called Empanada Mama's, but her name is Brooke Dodds. She built her following by serving her empanadas at festivals and farmers' markets. *Brooke Dodds.*

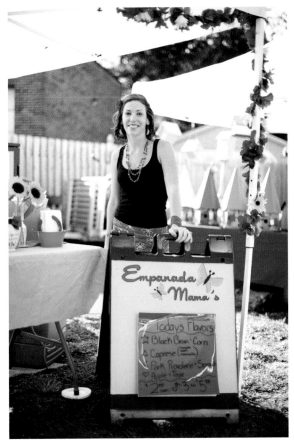

Colorful, playful and inviting Louisa's Café, the little eatery on Jackson Street that introduced farm-to-fork to Cape May.

Workers at Atlantic Cape Fisheries sorting through their harvest of Cape May Salt oysters. *Brian Harman.*

Cape May is an all-year community. Here are pumpkins of all different varieties harvested from one of the fields at Rea's Farm. (The author helped with the harvest.)

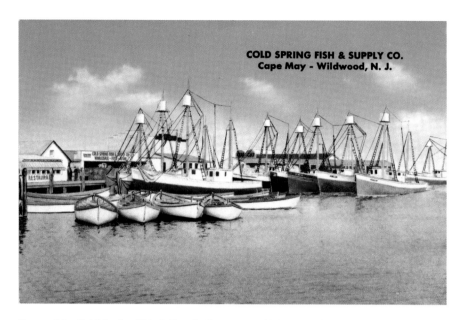

Postcard for Cold Spring Fish & Supply Company, which started in Wildwood and then made its home in Cape May in 1939. *Bunky Wertman.*

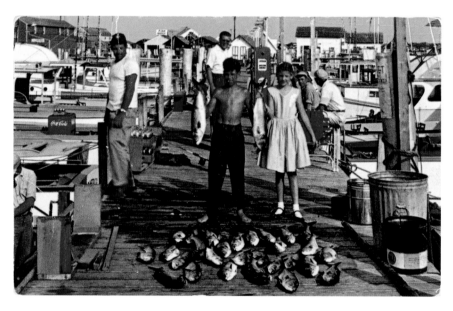

"Fishing is Good in Cape May," read the back of this postcard from the 1960s. And it looks like they might be right! *Bunky Wertman.*

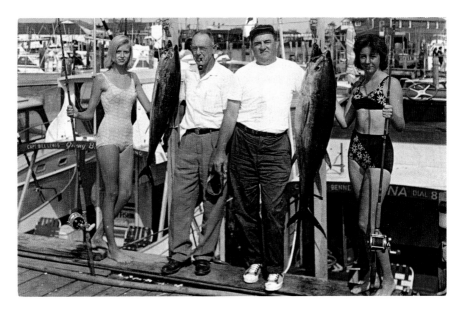

Another postcard from the 1960s touting sport tuna fishing in Cape May. *Bunky Wertman.*

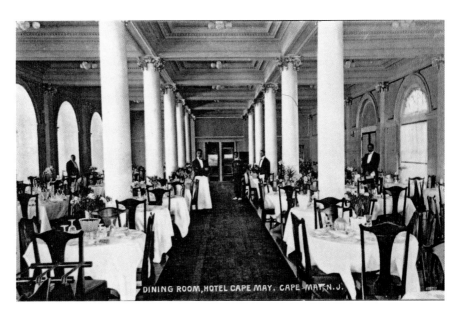

A postcard with a view of the opulent dining room at the Hotel Cape May. Sadly, the hotel would never live up to the hopes of those who built it. *Liz Pongia.*

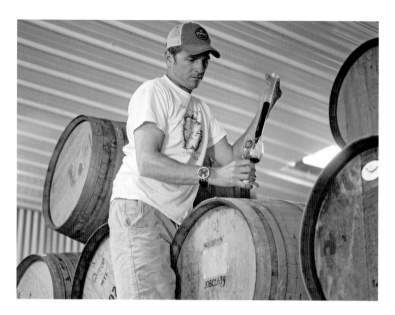

Winemaker and third-generation farmer Todd Wuerker taking a sample from one of his barrels at Hawk Haven Winery. *Hawk Haven Winery.*

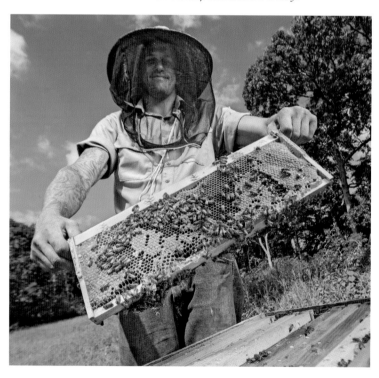

Beekeeping is another activity that takes place at Beach Plum Farm. Honey from the farm is made available for the public. *Cape Resorts.*

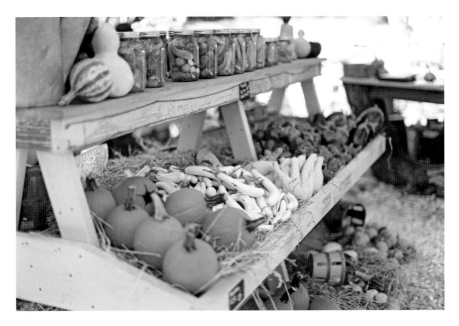

After getting Beach Plum Farm off the ground and producing, the next step was to add a farmers' market, which it did. The market is open year-round. *Aleksey Photography.*

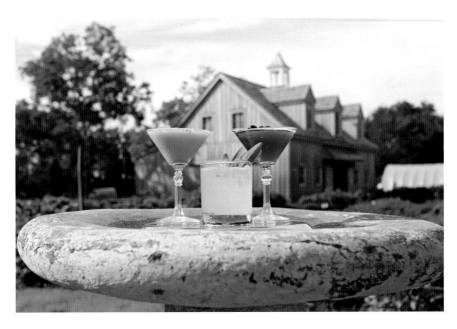

Farm-to-fork? How about farm-to-glass? A unique combination of ingredients from Beach Plum Farm makes for great cocktails at the Ebbitt Room. *Aleksey Photography.*

Looks good, doesn't it? Cape May scallops pan seared and served over a bed of vegetables. From the Ebbitt Room at the Virginia Hotel. *Aleksey Photography*.

A business card for William Essen's Bakery & Ice Cream Saloon from the latter half of the nineteenth century. The Essen name would be a part of the Cape May food scene from the 1870s to the 1910s. *Don Pocher*.

filled out cards from the New Jersey U.S. Crop Corporation that would provide information as to any farming experience they had. An example of one such card is as follows:[7]

> *Born December 11, 1927, he is 6' tall, 145 lbs., and a Sophmore [sic]. He is not a member of any club, but has taken Shop courses, he also has worked on a farm with farm machinery, hay raking and plowing, has also cut hay and hauled it, planted and cut corn. Other work experience includes Movies, Carpenter, Garden work, in Store and on boats and cars. Would prefer work Pitching Hay and cutting Corn. Is available April to June, would live at home, does also have a tent that he could live on the job if need arose.*

# The Lima Bean

In 1940, the farms of Cape May County had grown a record crop of a vegetable that people loved or hated: the lima bean. Although a Jersey lima had existed for some time, these crops were growing the Fordhook pole lima bean, which was grown for its size. This kind of lima bean was the product of the Burpee Seed Company in the early twentieth century, and it became popular not only for its size but also its ability to stay green in color even when dried.[8]

As late as 1950, there were as many as 125 farms in Cape May County that grew lima beans.[9] Back at that time, local company Seabrook Farms (a frozen vegetable supplier based out of Cumberland County) was the primary purchaser of the Fordhook lima, and as many as 5,000 acres were dedicated to growing limas. Rea's Farm in West Cape May would have anywhere from 700 to 1,200 acres dedicated to lima bean growing.

Hanover Foods from Pennsylvania worked with three different farms—Les and Ernie Rea in West Cape May, Ed Wuerker in Rio Grande and Ralph Sheets in Green Creek—to supply them with lima beans. By this time, only about one thousand acres were needed to meet the demands of Hanover.[10]

When Hanover Foods pulled its lima bean operations out of Cape May County in 1995, it was a death blow to the lima bean growers. At Rea's Farm, they now use seven to twelve acres to grow enough lima beans for its farm market and to have them on hand at the Lima Bean Festival. Yes, that's right: a lima bean festival!

Even though lima beans are not grown in large quantities anymore, that doesn't stop West Cape May from celebrating its Lima Bean Festival.

The heritage of the lima bean in West Cape May has been forever imprinted in the minds of many thanks to the annual Lima Bean Festival, which is held in early October. First organized in 1985, the festival celebrates

all things lima bean. Local restaurants come up with unique ways of serving the lima bean—from soups and salsas to ice cream (yes, you read that correctly). There's even a Lima Bena Queen crowned every year. The event has brought national attention to the little town of West Cape May. Crowd attendance at the Lima Bean Festival has been estimated at about ten thousand people.

## RECIPE: LIMA BEAN HUMMUS

*This recipe was graciously offered by Hilary Keever and Contrano Rosettani from Good Earth Organic Eatery in West Cape May.*

INGREDIENTS
4 cups cooked lima beans (approximately 2 cups dry)
good quality water or spring water
2-inch piece of kombu seaweed or kelp
2 teaspoons unrefined sea salt (to taste)
⅓ cup unrefined sesame oil
½ finely cut raw onion
handful of arugula or parsley (to taste)

DIRECTIONS
Rinse the uncooked lima beans three times and then soak them overnight in good quality water. The next morning, drain the beans and rinse again. Add fresh water to the soaked beans in a ratio of 1 part dry beans to 2½ or 3 parts water. Cook the beans in a pressure cooker for 1½ hours with a piece of kombu seaweed or kelp.

Once the beans are cooked, prepare 4 cups of the cooked and drained beans and place them in a food processor with 2 teaspoons of unrefined sea salt. Blend until the beans are creamy. Add ⅓ cup of unrefined sesame oil, ½ cup of finely cut raw onion and one handful of arugula or parsley. Blend again to mix well and salt to taste. Ready to eat with seasonal vegetables, bread, crackers or chips. Hummus can be kept for several days in the refrigerator.

# The Beach Plum

What grows like an oak tree, is harvested like an olive and then gets sorted like a blueberry? It is the beach plum, and it has a special place in the hearts of locals on the Cape. In fact, the beach plum is the official fruit of Cape May County. The beach plum can be found along the coast of North America from Nova Scotia to North Carolina…and nowhere else. This fruit was not brought to the New World from Europe, as it was already here.

Early explorers on the New World such as Giovanni de Verrazzano and Henry Hudson noted this unique plant. Verrazzano called them "damson trees" after the type of plum found in Europe. Hudson wrote of the abundance of "blue plums" along some of the rivers he explored. Plant taxonomist Humphrey Marshall would give the fruit its name of *Prunus maritima* in 1785.

While sandy ground and salty air make conditions for other fruits difficult, the beach plum likes it just fine, thank you very much. It is very common to see beach plum trees growing right behind the dune grass that line the shore. Not only do they produce an edible fruit, the beach plum actually helps with dune conservation.

Locals have their own secret harvesting locations where they fill up on their prized fruit. If you ask, they *might* tell you. Then again, if you're not a local yourself, you may just want to try an area farmers' market instead. The best time of year to look for beach plums is from late August to the middle of September.

What distinction does the beach plum have over a typical plum? Size, for starters. Beach plums are smaller, with the average circumference being about the size of a quarter. Flavor is another distinction. When you sink your teeth into a beach plum, you get an initial tartness that gives way to a sweetness that you would expect in a regular plum. If you eat a beach plum and do not get any tartness, the fruit is overripe.

While the beach plum is common knowledge among the residents of Cape May, getting the word out to larger regions has been a challenge. The Cape May County Beach Plum Association is one of a number of organizations along the East Coast that has been working on raising the profile of the fruit. In 2010, the beach plum was named the official fruit of Cape May County.

It is not just the farmers' markets where you can find beach plums in Cape May. Local restaurants have tapped into its culinary potential and have become big cheerleaders for the beach plum. Besides the obvious

A close-up of beach plums growing on a tree. Beach plums can grow like a tree in an orchard or like a bush along the beach dunes. *Joe Alvarez.*

usage as a substitute for regular plums, beach plums have found their way into ice cream, cocktails and even a beer brewed by Cape May Brewing. Natali Vineyards has made a beach plum wine using locally supplied plums.[11]

## Recipe: Beach Plum Jam

This is a recipe from the Cape May County Beach Plum Association:

> *Add one pound washed, ripe fruit to a large pot. Crush or prick with a fork. Add enough water to just cover the fruit, but the fruit should not float (approximately 8 cups of water).*
>
> *Cook over a low heat and then bring to a moderate boil for 15 to 20 minutes, until the fruit is soft and losing its color.*
>
> *Strain through one thickness of moistened cheesecloth or jelly bag.*

*Return the strained pulp to the pot, add another 8 cups of water, and boil for about 10 minutes. Skim off any froth that forms.*

*Strain again and save the juice. Mix the pulp and the juice, and concentrate by passing through four thicknesses of cheesecloth. Then add 6 cups of sugar and 2 ounces pectin and bring to boil again. Boil mixture 10–20 minutes. The mixture should thicken and is ready once it is thick enough so that two large drops forming on the back of a spoon meld or gel into one. Pour mixture into sterilized glass containers. Yield is about 18 ounces of jelly for every pound of fruit.*

## Farming in Cape May Today: Three Perspectives

In 1950, there were 29,212 acres of farmland in Cape May County. By 2007, the acreage of farmland had been reduced to just 7,976. With the nonstop

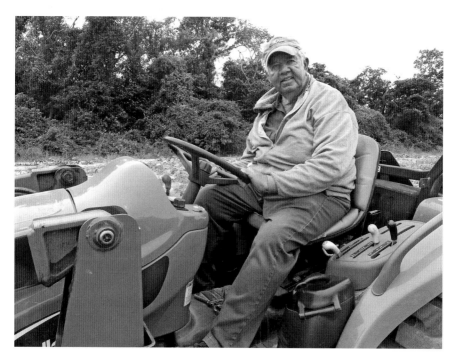

Leslie Rea, riding his tractor through one of the fields of his farm. Although down to ninety acres, Rea's Farm is still a big place that takes a lot of work.

drive of new housing developments and cost of land, not to mention the difficulty in a short supply of farm labor, keeping a farm going in Cape May County has been a struggle. Three farms—Rea's Farm, No-Frills Farm and Beach Plum Farm—give us a glimpse of what it means to be a farmer on the Cape in the twenty-first century.

Sometimes, you meet a person and you know that their choice of employment is perfectly suited to them. Shake the hand of Leslie Rea and you know right away that this man is a farmer. Stick around long enough at Rea's Farm, and Leslie might just get you to work out in one of his fields (as the author can vouch for, based on personal experience).

Rea's Farm was started by Leslie's father in 1936, and Les and his brother, Ernie, worked their thousands of acres for many decades. Now, Les and his wife, Diane, manage about ninety acres of farmland and a small farmers' market that features produce grown there and around South Jersey.

Through an agreement with local authorities, Leslie and Diane Rea gave over their rights to develop their land. Their acreage will stay as a farm. They believe that those who come to the farm should experience it as a farm. Too many of the ancillary activities that modern farms that are open to the public do today can get in the way of a true farm experience.

The hand-painted sign and the simple farm stand along Seashore Road seem to be appropriate for the name of the farm itself: No-Frills Farm. But

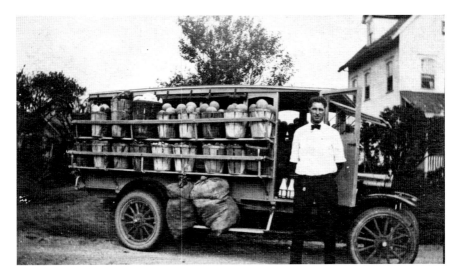

Walter P. Taylor, one of many Taylor generations to farm in Cape May. At one time, Walter P. Taylor served as a member of the State Dairy Advisory Committee. *Roy Baker.*

the moniker belies the history of the family who still believe in farming as a way of life.

No-Frills Farm is run by Charles and Kenneth Taylor, and the Taylor name dates back to colonial days. This particular farm has been in the family since the nineteenth century. Not only did the Taylor family raise fruits and vegetables, but they also had dairy cows for milk production and even beef cattle until 1990. The family has also grown soy beans, field corn and, of course, lima beans.

The Taylors of today work on fifty acres of farmland with a focus on vegetables and flowers. They are well-known for the variety of tomatoes that they grow, including many heirloom varieties that are not seen much these days. Charles will experiment with as many as fifteen different varieties of tomatoes.[12] What's interesting about this is that Charles Taylor does all this experimenting with tomatoes despite the fact that he doesn't even *like* tomatoes![13]

As a child, Curtis Bashaw helped out on his grandmother's South Jersey farm.[14] That experience stayed with him and brought him to making a purchase of sixty-five acres of abandoned property in 2007. The property became Beach Plum Farm. Now a number of Cape May restaurants, including those at Congress Hall and the Ebbitt Room, work directly with Beach Plum Farm for its produce and other foodstuffs.

The farm grows a wide variety of fruits and vegetables, from sweet potatoes and spinach to berries and melons. It has its own beehives for producing honey, and it has chickens and pigs for meat and eggs. The farm market is open all year, giving locals and visitors alike the opportunity to pick up some of the same food items that are being used in the restaurants. Even if you decide not to buy anything, the grounds are good for strolling around and seeing what crops are in store for the coming year.

Beach Plum Farm has been a dream come true for Bashaw. Even with all of the other projects he has been able to bring to fruition, including the rebirth of Congress Hall, he believes that Beach Plum Farm has been one of the most rewarding projects of his career.[15]

## End Story: Farmers and Toll Roads Don't Seem to Mix in Cape May

In 1854, the Cape May Turnpike Company was formed and proposed to build a toll road that would connect Cape May Court House and Cape

May. Road improvements were usually considered a good thing. This time, however, there were dissenting voices coming from the local farmers. Some held out for more money than what was being offered them. Others simply refused to go along with the plan. And then there was one farmer, John Tomlin, who refused to sell to the turnpike company for a road that would require farmers to pay a toll for bringing their goods to the markets and hotels of Cape May.[16]

And so, as an act of protest, John Tomlin did something about this new road: he went and had his own road built that ran parallel to the new turnpike. This toll-free dirt road would have its own name: Shunpike.

Fast-forward one hundred years. When the Garden State Parkway was making its way down along the Jersey Shore toward Cape May in 1953, local farmers were once again not all that thrilled with the idea. Legal battles over giving up land ensued, but the road would be built. The parkway opened up to Cape May in September 1954, and as the southern terminus to the new toll road, the famous shore town earned yet another nickname: "Exit 0."

If you're ever driving around between Cape May and Cape May Court House, look for County Route 644. The name of the road is known better by the locals as "Shunpike Road," the one that was built in protest back in 1854.

# SCALLOPS, SALTS AND THE PORT OF CAPE MAY

When people talk about Cape May, the discussion usually involves the beach, the beautiful Victorian homes, the restaurants, the diamonds and so on. But Cape May is still a working town, and at the heart of that is the port of Cape May. Having the Atlantic Ocean to one side and the Delaware Bay to the other, it only makes sense that seafood would be a major player in the story about Cape May's food history.

The Kechemeches fished and collected clams and oysters, as did the first settlers of European origin. Local seafood became a key industry to Cape May, as well as a major selling point to bring sea bathers here. Along the way, there would be events of consequence, good and bad, that would shape the industry. Today's Port of Cape May and the oyster beds on the bayside have been works in progress for centuries.

## WHALING OFF THE CAPE

Much has been discussed over the years about the relative success or failure of the whaling industry in Cape May from the late seventeenth century until the middle of the eighteenth century. We know for sure that whaling was a key component in bringing people to the Cape. We also know that whaling activity did take place. As far as it being a profitable industry in Cape May? That debate remains unresolved.

Thomas Leaming recounted his whaling activities in his journal. He came to Cape May in 1692 and was able to catch eight whales with the assistance of others, while driving five others onto the shore near where the town of Lewes, Delaware, is located today. He stayed one month while the driven whales were cut apart for their intended purposes.[1] Whaling activities continued off and on during the first half of the eighteenth century. Newspapers throughout the colonies published reports of whales being caught in Cape May. Six whales were captured in 1718.

Did the locals eat whale? While whale was known to be consumed in Europe around the time of the early settlements in North America, research on the colonists indicated that whale was not part of their regular diet. That being said, a will and inventory of one John Briggs from 1692 tells a possible different story. In this document, Briggs noted that he owned hogs that were modestly valued because his family "were all spoyled with eateing of blubber."[2]

# Protecting the Oyster Beds

From the earliest moments of the first permanent settlements on the Cape, the oyster became an important resource. Not only was it an important food source for the local residents, but the oyster also became vital to the area's economic growth as trade expanded to other parts of the New Jersey colony and to Philadelphia. The importance of the oyster was made clear by the steps taken to protect it.

On March 27, 1719, a law was passed by the New Jersey Assembly that stated that no person should rake or gather up the oyster or shells from May 10 to September 1. For nonresidents, they could not gather up any oysters at any time to take away with them, and doing so would make them subject to the penalty of forfeiting their vessels or equipment. Jacob Spicer and Aaron Leaming were put in charge of oyster inspection for Cape May County.

Spicer noted in 1758 that at least ten boats were in service of transporting oysters to market, making three trips in the springtime and the fall. Each boat was able to carry one hundred bushels. These shipments were primarily made to Philadelphia. For their troubles, the residents of Cape May earned six hundred pounds from the oysters they harvested.[3] In 1769, the assembly confirmed the 1719 law and added a penalty of forty shillings for those who did not obey the law.

The times of year when oysters could not be taken from their beds would change over the course of the eighteenth century. In 1774, it was from April 10 to September 1. The following year, it was from May 1 to September, which follows the old adage that you should only eat an oyster in a month that has an *r* in it.

Jacob Spicer got himself in some hot water with the Cape May locals over the oyster beds around Cape May. Spicer had made a purchase of the beds in August 1756. According to the journal of Aaron Leaming Jr. (who along with Spicer was one of the more prominent merchants in the county), an entry dated March 23, 1761, noted: "Meeting regarding claim ownership of Jacob Spicer to the oystery in Cape May. Spicer claimed he had purchased it for himself and not for the people."[4]

## Schellenger's Landing

As the community of Cape May developed into a destination for sea bathers, Schellenger's Landing became the location for fish outings. Want to know the best place to catch fish? Ask a fisherman. Want to know how to prepare the fish you plan on catching? Ask that same fisherman. The truth is that those with the skills and expertise to reap the bounty of the sea are usually quite adept at cooking their catches as well. On Cape Island, one such individual was Aaron Schellenger.

While his primary job was building boats and fishing, as well as running his dock on the ocean side of the Cape, the fishing excursions Schellenger led for the visiting adventurers were highly regarded and enjoyed. One of the highlights was the feast along the water, where the catches of the day were deftly served up thanks to Schellenger's cooking prowess. With Congress Hall providing the plates and silverware for these outdoor feasts, it would have been quite the dining experience. A visitor in 1829 gives a wonderful image of the meal:[5]

> *Imagine yourselves of a party, far away from the odious sight of brick walls and satin sofas, mahogany chairs and tables covered with fine linen, camped out like a troop of flying Arabs, the honest cook coming with pan after pan in quick succession, laying on your plate, piping hot, the trout, the perch, the flounder and the rock and the sheepshead and, better yet, the dear little thing about six inches long most aptly called here the goody that in very richness*

An advertisement for Schellenger's fish market from the *Cape May Star and Wave* in 1954. The Schellenger name has long been a part of Cape May's fishing history.

*melteth away in the mouth, the most delicate and sweet of all pan fish, with plenty of cool drink at your side with which to cheer your heart and pledge it to attendant beauty—brightest progeny of heaven!*

## Is an Oyster Wild or Tame?

It is hard to think of an oyster as a wild animal, but this very question was part of a state Supreme Court case that occurred in 1858. Thomas Taylor was charged with the theft of oysters from the oyster beds of George Hildreth to the tune of $1,800—not a small sum in those days. Taylor claimed that oysters were wild animals and, as such, were not subject to ownership. But these oysters had been planted by Hildreth where there was no naturally occurring oyster beds.[6]

What did the court decide? Oysters planted where they did not grow naturally were considered tame by the judge. Therefore, these oysters were considered as domesticated as the cows, sheep and chickens being raised on a farm on dry land.

## Goody Goody: What Was a Cape May Goody?

*Cape May goodies begin to coast along the Bayshore.*
                    —Cape May Ocean Wave, *August 1, 1885*

In some accounts from visitors of Cape May, one of the fish mentioned was called a "Cape May goody," or just simply a goody. The goody drew comparisons to the bony, oily menhaden (which seems unlikely), as well as to the hogfish. The best description comes from a brochure that was produced by the West Jersey Railroad Company in 1875, which notes that a Cape May goody is "a delicious salt-water fish the size of a perch."

Whatever type of fish it was, the Cape May goody seems to have long since departed from local waters. Other fish have also disappeared from the area, such as the sheepshead, which was a staple of the hotel dining tables for most of the nineteenth century.

## KING CRABS FOR...FERTILIZER?

*I cannot recommend a visit to Goshen beach for sweetness sake, for dying king crabs do smell, and that most foully.*
–Cape May Ocean Wave, *July 27, 1871*

When we hear someone say "king crabs," we immediately think of those monster-like legs filled with succulent meat. When it comes to sea arachnids, these are good eating. But in the nineteenth century, the king crabs harvested just north of Cape May served a food purpose, but not for eating. They were caught and grounded up for fertilizer.

During the months of May and June, these crabs would make their way to the bayside of the Cape and lay their eggs. Caught in the water by the thousands, the crabs were brought to a factory in Goshen and kept in pens until they died and dried up. Once dried, the crabs were easily ground up into a powder and then sold as a means to fertilize local farms.

For those who were looking for a better way to enjoy crabs, there was crabbing, or fishing for crabs, which has been the pastime of locals and visitors alike since there have been locals and visitors. For the hardcore crabbing aficionado, the method to catch crabs has not changed much. Taking a piece of raw meat, preferably the neck or the entrails of a chicken, you tie it to the end of a string, put it in the water and wait for the tug from crabby claws.

## RECIPE: OYSTER STEW

This recipe comes from a whole column of oyster-related recipes published in the *Cape May Ocean Wave* on September 27, 1870, by Mrs. A.J. Long.

*Put as many good fresh oysters, with their liquor, as you think you will need into a pan on the stove to heat, but not boil. Drain the juice off into a saucepan, as soon as it boils add half a pound of butter and some pepper; when this boils add a pint of cream and thicken a little with flour; after this boils up once, put in the oysters and more salt if necessary. Serve very hot.*

# Eating Porpoise (on Purpose)

*Porpoise steak has become so popular on the Jersey coast that the children blubber for it.*

–Star of the Cape, *March 20, 1885*

The notion of eating porpoise sounds vulgar and horrible to our modern sensibilities, but in the 1880s, this had the potential to become a big industry in Cape May. Many viewed porpoises not only as a source for food and oil but also as a rival in the supply of fish.

In 1884, the Cape May Porpoise Fishing Company was formed for the purpose of catching porpoise for the use of their oil and to turn their bones into phosphates for farming. The company bought two steamships, and with its patented fishing net, it planned to catch as many as five thousand porpoises during the year. The meat would not go to waste. Porpoise steaks were compared to venison in taste. Cured porpoise meat was sold as a substitute for dried beef in one location in Philadelphia.

But things did not go well for the company. One of the steamships, the *John Taylor*, ran ashore and broke up in November 1884. One of the founders of the company, George L. Sparks, left in the spring of 1885 and tried his luck at porpoise fishing off Cape Hatteras. And despite even getting a mention about the "success" of this new potential source of food in the *New York Times*, fishing for porpoise did not sustain itself as a viable industry.

# Recipe: Clam Pie

This recipe was provided by Carol Boyd, a longtime resident of the area. This was used by her mother, Elizabeth Hand Parker. As Carol shared, "She stretched the recipe a little more so as to feed a family."

*Sauté pork fat and onions. Finely diced potatoes and carrots. Cook until tender. Drain, add the saluted pork and onions. Add chopped clams to mixture reserving the clams juice. Season with Thyme. Make pie crust large enough to make a bottom and top crust in a 9 in pie plate. Line the bottom of the pie plate with crust. Add the clam mixture. Place top crust on and bake moderate oven (350 degrees) until done.*

*In the meantime, sieve the reserved clam juice. Make a white sauce using the clam juice. Hard boil 3 or 4 eggs. Thicken the mixture, add the slice Eggs. This mixture is served over the clam pie when it is plated.*

*(Mom knew the number of potatoes to use. I suggest 4 depending on the size. I also determine number of carrots [at] usually 3. The pie plate mixture should be plentiful enough to fill the pie plate. The more clams the better the pie. We usually use Cherry Stone clams. In other words, make lots of filling; using more clams makes a better product. I don't like the pie if there are too many potatoes. I like a heavy clam flavor.)*

## COLD SPRING FISH & SUPPLY AND THE LOBSTER HOUSE

There is a place where tourist Cape May meets working Cape May on a daily basis. This is not to say that there isn't work going on all over Cape May, but if you wanted to catch a glimpse of the Port of Cape May in

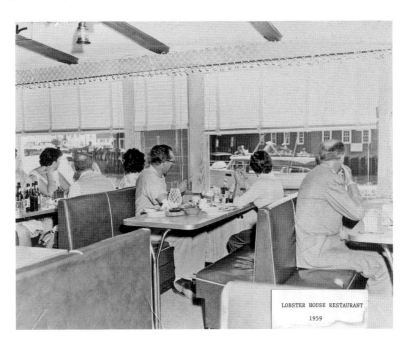

Dining at the Lobster House, watching the boats go by—just as enjoyable now as it was back in 1959 when this picture was taken. *Lobster House.*

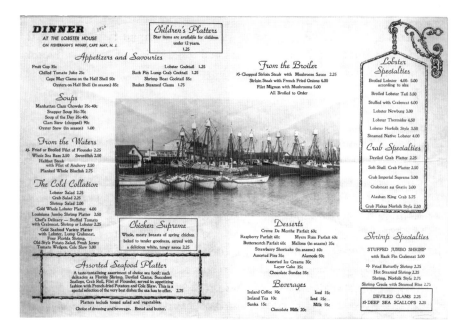

**DINNER** 1960
AT THE LOBSTER HOUSE
ON FISHERMAN'S WHARF, CAPE MAY, N. J.

*Children's Platters*
Star items are available for children
under 12 years.
1.25

*Appetizers and Savouries*

Fruit Cup 35c
Chilled Tomato Juice 25c
Cape May Clams on the Half Shell 50c
Oysters on Half Shell (in season) 85c

Lobster Cocktail 1.25
Back Fin Lump Crab Cocktail 1.25
Shrimp Boat Cocktail 85c
Basket Steamed Clams 1.75

*From the Broiler*

☆ Chopped Sirloin Steak with Mushroom Sauce 2.25
Sirloin Steak with French Fried Onions 4.00
Filet Mignon with Mushrooms 5.00
All Broiled to Order

*Lobster Specialties*

Broiled Lobster 4.00- 5.00
according to size
Broiled Lobster Tail 3.50
Stuffed with Crabmeat 4.00
Lobster Newburg 3.00
Lobster Thermidor 4.50
Lobster Norfolk Style 3.50
Steamed Native Lobster 4.00

*Soups*

Manhattan Clam Chowder 25c-40c
Snapper Soup 35c-70c
Soup of the Day 25c-40c
Clam Stew (chopped) 90c
Oyster Stew (in season) 1.00

*From the Waters*

☆ Fried or Broiled Filet of Flounder 2.25
Whole Sea Bass 2.50      Swordfish 2.50
Halibut Steak
   with Filet of Anchovy 2.50
Planked Whole Bluefish 2.75

*The Cold Collation*

Lobster Salad 2.25
Crab Salad 2.25
Shrimp Salad 2.00
Cold Whole Lobster Platter 4.00
Louisiana Jumbo Shrimp Platter 2.50
Chef's Delicacy — Stuffed Tomato
   with Crabmeat, Shrimp or Lobster 2.25
Cold Seafood Variety Platter
   with Lobster, Lump Crabmeat,
   Four Florida Shrimp,
   Old-Style Potato Salad, Fresh Jersey
   Tomato Wedges, Cole Slaw 3.00

*Crab Specialties*

Deviled Crab Platter 2.25
Soft Shell Crab Platter 2.50
Crab Imperial Supreme 3.00
Crabmeat au Gratin 3.00
Alaskan King Crab 3.75
Crab Flakes Norfolk Style 2.50

*Chicken Supreme*

Whole, meaty breasts of spring chicken
baked to tender goodness, served with
a delicious white, tangy sauce 2.25

*Desserts*

Creme De Menthe Parfait 60c
Raspberry Parfait 60c      Myers Rum Parfait 60c
Butterscotch Parfait 60c   Mellons (in season) 35c
Strawberry Shortcake (in season) 60c
Assorted Pies 35c          Alamode 50c
Assorted Ice Creams 30c
Layer Cake 35c
Chocolate Sundae 35c

*Shrimp Specialties*

STUFFED JUMBO SHRIMP
   with Back Fin Crabmeat 3.00
☆ Fried Butterfly Shrimp 2.25
Hot Steamed Shrimp 2.25
Shrimp, Norfolk Style 2.75
Shrimp Creole with Steamed Rice 2.75

*Assorted Seafood Platter*

A taste-tantalizing assortment of choice sea food; such
delicacies as Florida Shrimp, Deviled Clams, Succulent
Scallops, Crab Roll, Filet of Flounder, served in appetizing
fashion with French-fried Potatoes and Cole Slaw. This is a
special selection of the very best dishes the sea has to offer.  2.75

Platters include tossed salad and vegetables.
Choice of dressing and beverage.  Bread and butter.

*Beverages*

Ireland Coffee 10c
Ireland Tea 10c            Iced 15c
Sanka 15c                  Iced 15c .
                           Milk 15c
Chocolate Milk 20c

DEVILED CLAMS 2.25
☆ DEEP SEA SCALLOPS 2.25

Menu from the Lobster House in 1960. Notice that there is almost no mention of scallops (with one exception) on the menu. *Lobster House.*

action, make a trip to the Lobster House, just over the bridge from the end of the Garden State Parkway.

The Lobster House, which is part of the Cold Spring Fish & Supply Company, has been a part of the Lauderman family since the 1920s. Jess Lauderman began the Cold Spring Fish & Supply Company in 1926 in Wildwood but would eventually find his permanent home for this company at Schellenger's Landing in 1939. Part of the property that he purchased included a restaurant, which he would lease out.

In the early 1950s, Jess gave his son, Wally, the keys to the restaurant and told him to do something with it. And he did, changing the name to the Lobster House and forever changing the course of dining in Cape May. In the 1960s, Wally bought a schooner, named it the *Schooner America* and made it into a cocktail bar. Outdoor dining and a raw bar were also added along the way.

For those who prefer to cook things themselves, there is the fish market attached to the restaurant. A wide variety of seafood can be found for purchase, and there's no question as to how fresh the fish is and where it comes from. You just have to look outside to know that.

Over the years, the Lobster House has had to deal with adversity. But two major fires and flooding from storms over the years have not deterred Keith

Lauderman, the current generation of the Lauderman family to run the business. He also recently suffered personal tragedy, losing his sister, Donna, who had worked in the restaurant for most of her life.

## The Near Death of the Oyster Industry

The oyster industry along the Delaware Bay continued to be profitable until 1957, when disaster struck. An oyster pathogen known as *Haplospordium nelsoni* found its way into the waters of the Delaware Bay, and a disease called MSX (short for multinucleated sphere unknown) would attack the oysters in the bay. The effects were devastating. The mortality rate was estimated at 90 to 95 percent of all the oysters in the Delaware Bay.

Slowly, the oyster population started to recover. But in 1991, the arrival of another disease known as DERMO delivered what seemed to be the knockout blow for the oyster industry. Death rates for oysters in 1991 was at 80 percent. Oyster boats literally rotted in the bay, sitting in docks unused.

## The Cape May Salts of Yesterday and Today

Regardless of where one finds oysters along the eastern seaboard, they are all of the same variety: *Crassostrea virginica*. And yet each region that has its own oyster will tell you there is a difference in flavor. Cape May Salt oysters get their distinct flavor from their location, which is low enough in the Delaware Bay that it contains a level of brininess that is different from oysters harvested farther up the bay in places such as Port Norris and Bivalve in Cumberland County.

Back in the nineteenth century, there was more to oysters along the bay than just Cape May Salts. There were also Bay Shore Primes, also referred to as Pierce's Point Primes because of where they were harvested. These oysters were said to have fetched a pretty good price at the markets in Philadelphia.

The Cape May Salt oyster that is harvested now is different from the ones that populated the bayside of the Cape in the nineteenth century. For one thing, oysters harvested back then grew in clumps and needed to be separated by a knife. The modern oyster that is now cultivated is called a "clutchless" or "single" oyster and does not require the need to be separated.[7]

Here it is: a Cape May Salt oyster on the half shell, ready to be enjoyed (which the author eventually did, along with a few of his friends).

The oysters that are harvested along the Delaware Bay side of the Cape are the product of a coordinated effort between the Rutgers Aquaculture Innovation Center based in North Cape May and the local oyster farmers. The Innovation Center grows and cultivates the baby oysters and then sells the seeds to the local oyster farmers. Some baby oysters are donated to organizations that are using oysters to help in the restoration of coastal ecosystems.[8]

The baby oysters are grown by the oyster farmers using a system called the "rack and bag," where they are kept in mesh-like bags and sit just above the shore. The result is an oyster that has a nice shell as well as flavorful meat inside.

The importance of protecting the Cape May Salt as a regional food was demonstrated by the slow food movement. Slow Food USA recognized the Cape May Salt oyster as worth preserving because of its value in the region and also its impact on the environment. This was the first time Slow Food USA had bestowed this level of importance to any regional food in the United States.

Advertisement for Chambers Fish Market from 1933 in the *Cape May Star and Wave*. Chambers was a part of the market scene on Mansion Street for many decades.

## CAPE MAY IS A SCALLOP TOWN

With an oyster named after the town, one would believe that Cape May Salts would be the big seafood industry at the Port of Cape May. But the biggest catch here, by far, is sea scallops. The annual haul of scallops brought in to the Port of Cape May makes it the second-busiest commercial seaport on the East Coast.

How did the little scallop become such a big part of Cape May's commercial fishing industry? The story goes that back in 1965, there were these two scallop boats from New Bedford, Massachusetts, that had ventured south looking for good spots to catch scallops and got caught up in a storm. Finding shelter in Cape May, they unloaded their scallops haul at the Lobster House dock.[9]

By the middle of the next decade, Cape May commercial fishermen were upgrading their boats and venturing out themselves into the rich scallop-laden section of the Atlantic Ocean called Hudson Canyon (about seventy-five miles out to sea). The Port of Cape May would never be the same.

Over the past forty years, scallops have become a regular part of our seafood diet. And those who live on the East Coast can be grateful that Cape May fishermen continue to deliver plenty of *Placopecten magellanicus* to our restaurants, fish markets and grocery stores.

## End Story: The Statue at the End of Missouri Avenue

If you drive to the end of Missouri Avenue, you will come to a sacred spot. In 1988, a statue was dedicated to those fishermen who have been lost at sea. It's a simple yet stark reminder that those who harvest the seas are exposed to the weather from above and the strong waves below. And sometimes a fisherman doesn't come back. The names of those who have not come back are listed on a separate memorial next to the statue.

The statue is of a mother with her two young children. They look to her for answers, but she can only look out at the water, holding her children, unable to answer their questions.

The statue and memorial to the fishermen lost at sea, erected in 1988. It is located at the end of Missouri Avenue.

Chapter 8

# VINEYARDS BY THE SEA

*We can see no good reason why the Southern part of New Jersey should not become a wine growing country.*
—Trenton State Gazette, *January 11, 1858*

Since the days of colonial America, the southern part of New Jersey has been known for its ability to grow wine grapes. But the current wine industry in Cape May is a much more modern phenomenon, having only been in existence for the past twenty years (as of the publishing of this book). The journey to the modern wine industry had some obstacles to overcome.

The making of wine, like the making of beer, was done at home primarily by the women of the households. Grapes were sold to be made into wine, as well as to be used as outdoor decoration. Cookbooks of the early nineteenth century contained recipes for winemaking. Published in 1803, *The Frugal Housewife, or, Complete Woman Cook* listed several recipes for wine made from all different kinds of fruits.

In October 1861, an article appeared in the *Cape May Ocean Wave* that told about a trip to the farm of W.B. Miller, which was a mile and a half from Cape Island, and to his vineyard, which was described as "the only one, to our knowledge, in the county; and it is, therefore, quite a novelty."[1] The vineyard was three acres in size and had been started three years earlier by planting the cuttings from vines that were being grown in peoples' yards. There is no mention of Mr. Miller making any wine himself, only that he was intending to sell his grapes to market.

Whether Mr. Miller's farm was the only one at that time with a vineyard is debatable. But there was no question that by the 1870s, other farmers in Cape May County were growing wine grapes and making wine. A visitor to the region at that time remarked that there were vineyards dotting the scenery and that every farmer had his own wine cellar.[2]

But these burgeoning vineyards would be decimated by two great forces. The first would be a plague of black rot that destroyed the vines in the 1880s.[3] After making a recovery to the tune of 144,000 pounds of grapes harvested in 1909 in Cape May County alone,[4] the second—and even more devastating—force emerged that would take the wine industry decades to recover from: the prohibition movement. While trying to keep its businesses afloat through selling tonics for medicinal purposes or grape juice for health benefits, the wine industry in Cape May and all over New Jersey would become nonexistent. Adding insult to injury would be the post–World War II home-building boom that would reduce the amount of farmland available.

From these conditions, somehow, miraculously, the wine industry in Cape May would be reborn.

## The Modern Wine Industry

When you have the temperate conditions similar to other winemaking regions in the world, such as France's Bordeaux region, it only makes sense that wine grape growing would be part of the landscape in Cape May. The proximity to the ocean and the bay allows Cape May to have a growing season that is six weeks longer than any other part of New Jersey. And so, despite the archaic Prohibition-era laws that held back progress, the wine industry in Cape May has now flourished over the last quarter of a century. Several wineries have now established themselves as part of the agricultural landscape.

This generation of wine growers has had to do much research and work on the most basic of questions: what varieties grow best in this region? Having a climate that resembles Bordeaux lends itself to growing similar grapes. An example of that is Cabernet Franc, which has done well in the sandy soil. A French-American hybrid, Chambourcin, has also flourished. In 2006, Cape May was designated as part of a wine-growing region called the Outer Coastal Plain American Viticultural Area.

But these modern winemakers serve another purpose. By taking over abandoned or unprofitable farms, these individuals are helping to preserve

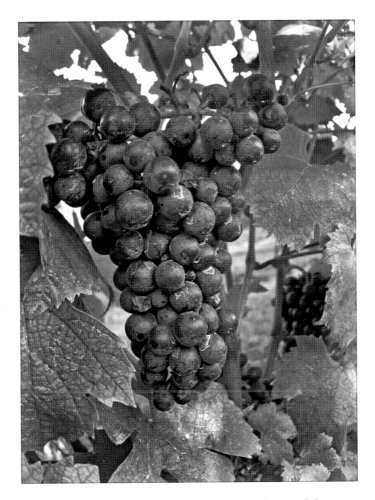

Wine grapes growing on the vines at Natali Vineyards, one of six
wineries located in the Cape May region.

farmland. And their efforts have led not only to a vibrant industry but also
to a further expansion of tourism. Wine tours throughout the Outer Coastal
Plain region have become regular events.

## THE WINEMAKERS OF CAPE MAY

It seems altogether fitting and proper that today's wine industry in Cape
May began with two people who had no experience as winemakers. But Bill

and Joan Hayes, self-taught in the ways of winemaking, decided to make their dreams come true. With the help of consultants from Rutgers University (which has become a standard practice in New Jersey whenever a new vineyard is in planning), Cape May Winery opened for business in 1995. And today it is still the most well known of all the wineries in Cape May.

But along the way, Bill and Joan had to learn lessons the hard way. Early on in the growing process, their lack of protective netting allowed birds to eat their fruit. In a twenty-four-hour period, they lost three-quarters of their crop.[5]

In 2002, the winery was purchased by Toby Craig, the owner of the Washington Inn. Craig had already started growing grapes in his own winery, called the Isaac Smith Vineyard. Isaac Smith was a coffin maker in the early nineteenth century, and the vineyard is now growing where Smith lived. In honor of Isaac Smith, the wines made from that vineyard feature a label with a casket on it.

As for the rest of their wines, Craig and winemaker Darren Hesington produce a wide variety of dry and sweet wines. Chardonnay, Merlot, Cabernet Sauvignon and Syrah are the featured grapes here. And while you enjoy one of their wines, enjoy their beautiful and expansive tasting room complete with several oak barrels or head upstairs to the outdoor porch that overlooks some of the vineyard for a wonderful view.

Once a dairy farm that eventually grew lima beans, Hawk Haven shifted course and became a winery in 1997. That was the year brothers Todd and Ken Wuerker planted their first Cabernet Sauvignon vines. The farm where Hawk Haven is located has been part of the Wuerker family since Felix Wuerker came to Cape May from Germany in 1940. The brothers are the third generation to be in charge of the farm, and they have quickly made their winery a destination for wine lovers touring the Cape.

The tasting room opened in 2009, and ever since, Todd and his wife, Kenna, have created a fun and relaxed environment throughout their one-hundred-acre farm. Hawk Haven currently grows as many as sixteen different varieties of grapes over fourteen acres, many of which have become typical to the Outer Coastal Plain: Cabernet Franc, Chardonnay, Viognier and Chambourcin. But Todd Wuerker has also grown some interesting choices as well, such as Gewurztraminer and Albariño. They even produced a port with Moscato grapes.

It is a long way from New Zealand to Cape May, but it was a trip to the former that led to the inspiration to start a winery at the latter. While visiting New Zealand ten years ago, along with a stop at the Alexander Valley in California, Bruce Morrison developed a passion for winemaking and began

to look for his own space to do so. And he found it while traveling on his motorcycle in 2006: a former lima bean farm along Delsea Drive in Cape May Court House. Along with his partner, they started Jessie Creek Winery.

By 2012, when the winery officially opened for business, Jessie Creek was producing wines that were winning medals at state competitions. The grape varieties they have focused on at Jessie Creek are Cabernet Savignon, Merlot, Chardonnay, Pinot Grigio and Chambourcin. The winery has also produced its share of fruiter wines using local cranberries, blueberries and concord grapes. Along with the winery, Jessie Creek has taken a farmhouse on the property that dates back to 1846 and turned it into a bed-and-breakfast.

Dr. B (as Bruce likes to go by) sees South Jersey and the Outer Coastal Plain region as the new Napa. As the wines get better in the area, he believes, the wine tourism trade will grow along with it.[6]

It's not usually the historian who makes the history, but historian and brokerage house network engineer Al Natali has become a part of the modern history of the Cape Way wine region. Natali and two partners purchased a twenty-two-acre horse pasture near Goshen in 2000 and began planting vines the following year. By 2007, Natali Vineyards was open to the public for business.

But like any good historian, Al Natali embarked on further research in winemaking, taking courses in wine chemistry and other areas of relevancy, gaining further knowledge of his craft. Wines have been produced with grapes both known and not so known. And experimentation with playful themes has become a hallmark of Natali. They would not be insulted if you called them a bit fruity, since many fruits (outside of grapes, of course) have found their way into the bottles of Natali. Pineapples, blueberries, cranberries and peaches have been made into wine. They have even made a banana dessert wine—an award-winning one at that. Even the official fruit of Cape May County, the beach plum, was made into a wine by Natali.

Salvatore Turdo's life has always been touched by wine. As a young boy in Sicily, he remembered his family making wine. After making his way to Paterson, New Jersey, he made wine in his garage with bought grapes. And when he imagined his life after retirement, Turdo envisioned himself pursuing his winemaking hobby.

In 1998, Salvatore made his dream a reality when he purchased a six-acre horse farm in North Cape May that had been abandoned and become overgrown. Based on his research, the Cape May region's climate made it most suitable for growing wine grapes. And it was here where he and his

son, Luca, planted their first vines that would grow into the award-winning Turdo Winery.

In its early years, Turdo grew wine grapes that were known to do well in New Jersey's climate, such as Chambourcin and Cabernet Franc. After about six years or so, Salvatore decided to start growing wine grapes closer to his heritage, such as Nebbiolo, Sangiovese and Nero D'Avola. From these grapes Turdo began to produce wines that were truly unique to the region.

Turdo wines are 100 percent made from the grapes grown on the estate, and it makes no compromise in the quality of its wines. About 10 to 20 percent of its grapes do not get used in the winemaking process. That commitment to quality has forced them to have to close before the summer season is over due to being sold out. But the Turdo family believes strongly in quality over quantity, and they view selling out early as a nice problem to have.

Luca Turdo, who has worked on a full-time basis at the winery since 2007, has also branched out on his own to produce a line of wines under the Vini DiLuca name. These wines are a blend of New Jersey and California grapes. Just like his father, Luca has been touched by winemaking all his life and continues the tradition.[7]

It takes forces of nature to make wine grapes grow, including the right amount of sun and rain. Seated next to the beautiful Southern Mansion bed-and-breakfast, Willow Creek Winery has been growing due to another force of nature: the owner, Barbara Hamilton Bray-Wilde. After having bought and brought back to life the Southern Mansion as an exquisite bed-and-breakfast, she then set her sights on her winery. Willow Creek opened in 2012.

The land where the winery is located was once a farm owned by J. Elias Rutherford, who was the owner of the Mount Vernon Hotel and would grow produce here that was used for the hotel. He would also have carriage rides for his guests to come out and view the farm.[8]

Willow Creek grows grapes that have performed best in loamy, sandy soil and extra-long growing seasons. You can find Cabernet Sauvignon, Sauvignon Blanc, Merlot and other grapes that enjoy the sun and sea air of Cape May. Also available are more playful options such as blackberry Merlot and Wilde Cock Apple, an apple wine made with Jersey apples.

# End Story: And Don't Forget the Beer!

For most of its history, Cape May did not have a beer story to tell. Most beer sold in the hotels and taverns was brought in from outside—or, if it was brewed on the premises, those recipes have been lost. But since history is a story that is constantly being written and expanded on, the story of beer in Cape May has now become one of vibrancy.

With the relaxing of state laws in New Jersey regarding microbreweries, there has been an explosion of new breweries all over the state. One of the great success stories to come from this new wave of brewers is Cape May Brewing, which opened its doors in 2011. Finding a home at a regional airport in Rio Grande, partners Ryan Krill and Chris Henke left their corporate lives behind and pursued their sudsy dreams.

On any given day, and the brewery is open every day, Cape May Brewing will have twelve to fifteen different beers on tap. On more than one occasion, the brewers have reached into Cape May's past for inspiration, such as Sawyer's Swap Barleywine Ale or Poverty Beach Belgian IPA. The brewery also connects with Cape May's present with brews that have used local beach plums as well as honey. In fact, its Honey Porter became the first beer in New Jersey to get the designation "Made with Jersey Fresh," which is adorned on every label of the beer.

The success of Cape May Brewing, which expanded its facility in 2015 in order to keep up with demand and still allow for growth, has encouraged other local brewers to make their mark in the beer industry. Slack Tide Brewing in nearby Clermont (just north of Cape May Court House) opened for business in December 2015. And another microbrewer in Rio Grande, 7 Mile Brewery, is slated to begin operations in the summer of 2016.

Chapter 9
# Modern Dining in Victorian Splendor

Two centuries after Ellis Hughes published his advertisement for seashore entertainment, Cape May has once again found its sweet spot. The grand old seashore resort town finds itself in the new millennium comfortably embracing its past while also providing space for the wants and tastes of the beachgoers of today. The modern traveler and diner enjoys a wide variety of flavors and experiences, and Cape May does its best to meet those demands.

## Congress Hall for the Twenty-First Century

In June 2002, after two years of reconstruction and more than $20 million spent, Congress Hall was ready for its debut in the twenty-first century. And what a hotel it was to behold! Its golden yellow painted coating and long, signature columns never looked better. Curtis Bashaw and his company had created a masterpiece encased in brick.

The Big House by the Sea had been turned into a modern resort hotel. Each room had a feel of an age gone by and yet contained the modern conveniences, complete with flat-screen televisions. One end of the hotel had a day spa for those seeking that extra bit of relaxation and pampering. Full cabana service was available for those who wanted a drink while burying their toes in the sand.

And then there was the dining and cocktails. The Blue Pig Tavern provided indoor and outdoor upscale casual fare, leaning heavily on locally sourced ingredients from the land and sea. The name itself was taken from an infamous gambling house from the nineteenth century that was supposedly secret (yet quite well known). Young men were known to get a little drunk and then get taken to the cleaners by the more experienced card sharks at the Blue Pig.

The modern Congress Hall also had two bar locations. Next to the hotel lobby was the Brown Room. As the name indicates, the furnishings were indeed a deep, rich brown color. Located where the cocktail bar was that welcomed the end of Prohibition, the Brown Room had the look and feel of a bar from the 1930s. Sit around with your drink long enough and you might feel like an Agatha Christie murder could break out at any moment. Down below where the old boiler room was located was the other bar, called, fittingly enough, the Boiler Room. For lively evening entertainment, this was the destination.

During the renovation process, a box was discovered that contained china, sugar bowls and creamers from the nineteenth century. Based on their design, complete with the name of the hotel adorned on each item, the hotel was able to get reproductions made in time for the hotel's opening. This demonstrated the delicate balance between the past and the present that the modern Congress Hall handled with such grace.

If Thomas H. Hughes were able to break the laws of time travel and see the Big House by the Sea today, he would be astonished and pleased to see the life and vibrancy that still existed as it celebrated two centuries of accommodating seaside visitors.

## RECIPE: HONEY GLAZED SCALLOPS WITH BUTTERNUT SQUASH PUREE AND TOMATO JAM

*Congress Hall's Executive Chef Jeremy Einhorn was kind enough to provide this scallop recipe that focuses on local ingredients. The recipe will make four appetizer-sized portions.*

*INGREDIENTS*
*1 butternut squash, medium dice*
*1 tablespoon fresh garlic, chopped*
*1 sprig fresh thyme*

1 bay leaf

2 cups light cream

2–4 cups (as needed) milk

salt and pepper (as needed)

4 cups ripe red tomatoes, small dice

1 vidalia onion, small dice

1 cup rice wine vinegar

½ cup water

½ cup sugar

12 scallops, u10 size*

cooking oil

1 tablespoon beach plum farm honey

1 teaspoon rice wine vinegar

very small pinch cayenne

### Method for Squash

In a heavy-bottom stock pot, combine the squash, garlic, thyme and bay leaf with the cream. Add enough milk to cover all of the ingredients. Bring to a boil and reduce to a simmer. Add salt and pepper to taste. When tender, remove from the heat. Take the thyme sprig and bay leaf out. Strain the squash from the cream, but be sure to reserve the cream. Allow to cool slightly. Puree the squash in a food processor, adding just enough of the reserved cream to make a smooth puree. You can either gently reheat the puree before serving or serve at room temperature.

### Method for Tomato Jam

While the squash is cooking, combine the tomatoes, onion, vinegar, water and sugar in a nonreactive pan. Bring to a boil and reduce to a simmer. Allow to cook down until slightly thick. Remove from heat and cool. Season with salt and pepper.

### Method for Scallops

Remove the small abductor muscle from the side of the scallop. Pat dry with a paper towel and season lightly with salt and pepper. Heat the oil in a heavy-bottom pan on high heat. When it just begins to smoke, carefully place the scallops in the pan. Sear on each side until golden brown. Time will vary based on your stove top, but the hotter and quicker the better. Mix together the honey, vinegar and cayenne. Bring to a light boil over medium heat. Lightly paint the glaze on the finished scallops.

*To Plate*
*Place the puree on the bottom of the plate or bowl. Arrange three scallops*
*on top of the puree and garnish with the tomato jam.*

*\*Note*: Be sure to purchase dry packed scallops. Wet packed scallops are treated with sodium tripolyphosphate, a chemical that causes the scallop to soak up water before the freezing process. This plumps up the scallop and increases the weight before sale. When you cook a wet pack scallop, this liquid will bleed out, and you will end up with dry, rubbery, shrunken scallops. If you are able to find "day boat" scallops, that's even better. Day boat scallops (or any other day boat fish) are from fishing vessels that were only out for one day. Longer fishing trips require the boats to freeze the product, which reduces the quality. Day boat scallops are much fresher and have never been frozen.

# Vintage Cape May

These are the places that have withstood the test of time, be it fire, storm or changing tastes. Their continued presence has helped to define the food and dining scene in Cape May. It would be difficult to imagine this shore destination without them.

Captain Henry Sawyer, the Civil War hero who was saved from execution, built the Chalfonte in 1876. The hotel survived the fire of 1878 intact, making it the oldest hotel in Cape May. (Congress Hall traces its history back to 1816 but had been rebuilt twice due to fire; the current Congress Hall was built in 1879.) And in 1879, the dining room was added as part of a one-hundred-foot-long addition to the hotel.[1]

But the Chalfonte didn't start to become the place that is loved to this day until Susie and Calvin Satterfield from Richmond, Virginia, purchased the hotel in 1911. The new owners began to staff their place with employees from the South, including those who would be working in the kitchen. And in the kitchen is where Helen Dickerson learned how to cook in the southern style. Dickerson would rule the kitchen at the Chalfonte for five decades, having her down-home cuisine adored by locals and visitors alike in the Magnolia Room dining area until her passing in December 1990.

Helen had help in the form of her two daughters, Dot (Burton) and Lucille (Thompson). Dot and Lucille grew up in the kitchen of the Chalfonte, much like their mother, and kept the cooking traditions intact.

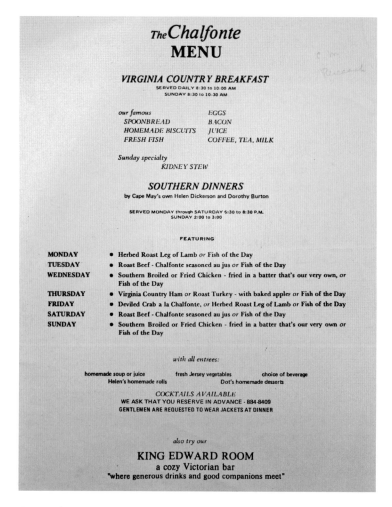

The*Chalfonte*
# MENU

### VIRGINIA COUNTRY BREAKFAST
SERVED DAILY 8:30 to 10:00 AM
SUNDAY 8:30 to 10:30 AM

*our famous*                    EGGS
SPOONBREAD              BACON
HOMEMADE BISCUITS   JUICE
FRESH FISH                   COFFEE, TEA, MILK

*Sunday specialty*
KIDNEY STEW

### SOUTHERN DINNERS
by Cape May's own Helen Dickerson and Dorothy Burton

SERVED MONDAY through SATURDAY 5:30 to 8:30 P.M.
SUNDAY 2:00 to 3:00

**FEATURING**

| | |
|---|---|
| **MONDAY** | ● Herbed Roast Leg of Lamb *or* Fish of the Day |
| **TUESDAY** | ● Roast Beef - Chalfonte seasoned au jus *or* Fish of the Day |
| **WEDNESDAY** | ● Southern Broiled or Fried Chicken - fried in a batter that's our very own, *or* Fish of the Day |
| **THURSDAY** | ● Virginia Country Ham *or* Roast Turkey - with baked apples *or* Fish of the Day |
| **FRIDAY** | ● Deviled Crab a la Chalfonte, *or* Herbed Roast Leg of Lamb *or* Fish of the Day |
| **SATURDAY** | ● Roast Beef - Chalfonte seasoned au jus *or* Fish of the Day |
| **SUNDAY** | ● Southern Broiled or Fried Chicken - fried in a batter that's our very own *or* Fish of the Day |

*with all entrees:*

homemade soup or juice        fresh Jersey vegetables        choice of beverage
Helen's homemade rolls                Dot's homemade desserts

*COCKTAILS AVAILABLE*
WE ASK THAT YOU RESERVE IN ADVANCE - 884-8409
GENTLEMEN ARE REQUESTED TO WEAR JACKETS AT DINNER

*also try our*
### KING EDWARD ROOM
a cozy Victorian bar
"where generous drinks and good companions meet"

A menu from the Chalfonte during the time that Helen Dickerson was still in charge of the kitchen. *Cape May County Historical Society.*

That included using some of the original cast-iron skillets for making their famous fried chicken. One of those pans measures out two feet wide and is capable of fitting a dozen chicken quarters.[2]

The cookbook the three ladies worked on together, published in the 1980s, reflects the simple yet profound food they have produced over the decades: *I Just Quit Stirrin' When the Tastin's Good.* The name came from Helen herself, in an attempt to explain her cooking methodology.[3]

Now, about that fried chicken. Not only does it have its adoring fans who come year in and year out, but it has also attracted national attention. Phil

Donahue showcased Helen Dickerson on his television show in 1984. Chef Tyler Florence declared the fried chicken at the Chalfonte to be the best in the country on a show for the Food Network.

Sadly, we lost Dot Burton in 2015. But Lucille Thompson and her staff continue to bring a little bit of the South to Cape May. And Dot's legacy continues as well; her son, Jimmy Burton, is currently the executive chef at the Beach Shack in Cape May.

First opened in 1885 as the Collins Café (the owner was named Patrick Collins), the Merion Inn eventually got its current moniker in 1906. A group of Philadelphia partners, led by Andrew Zillinger, purchased the place and renamed it after the Merion Club. Zillinger was actually the chief steward at the Merion Club, and his partners were members of the Merion Club who provided the financial backing.

The Merion Inn built its reputation for steaks and regional seafood, a good martini and, in later years, sophisticated live music. It became the place to hear jazz in Cape May, thanks to pianist George Mesterhazy. Sadly, George passed away in 2012. Despite some hard times, including a fire and financial difficulties, the Merion Inn continues to plug along.

Harry Redding's C-View Inn, which calls itself "Cape May's Oldest Tavern," opened for business on Schellenger's Landing in 1917. The origin of the name is still a bit of a mystery. The best theory out there is that the local bar took its name from the fact that you

An advertisement in the *Cape May Star and Wave* from 1942 for Harry Redding's C-View Inn, making drinks just the way you like them.

could look out onto the water and see the "C" buoy. Located away from the main activity of town, the C-View is where the locals go to hang out and enjoy one another's company. The spot is also known and loved for its chicken wings, and every town needs a good place for wings, right?

Ever since Naum Kahn opened his café on the corner of Washington and Decatur Streets in 1926, it has been a center of food and drink activity for locals and visitors alike. Naum's son, Sam, took over Kahn's Café in 1949, and the home to the "Royal Order of the Ugly Mugs" became known as the Ugly Mug. The history of "the Mug" is adorned all over the shelves and

**KAHN'S RESTAURANT**

AT THE SIGN OF THE RED LOBSTER

*426 Washington Street*

*Keystone Phone 1551*

MODERN BAR and DINING ROOM on FIRST FLOOR
FAMILY DINING ROOM on SECOND FLOOR

**Full Course Luncheons and Dinners 50c**

CLUB BREAKFASTS 6:00 to 11:00 A. M.

LEADING BRANDS {**BEER**} ON DRAUGHT ON ICE TO TAKE OUT

Long before it was called the Ugly Mug, it was Kahn's Restaurant "at the sign of the red lobster." This is an advert that appeared in the *Cape May Star and Wave* in 1933.

ceiling in the form of ceramic mugs. Each mug has the name of its owner and the year they obtained the mug. When a mug owner passes, their mug is turned toward the ocean as a sign of respect.[4]

Care to put your beer froth–blowing skills to the ultimate test? The Ugly Mug has hosted a Froth Blowing Contest every August for as long as people can remember, and a trophy and bragging rights are at stake. The Ugly Mug is also the host of a unique event that takes place all over the world. Every January, the haggis is celebrated as the main course of its Robert Burns supper. This dinner, which originated in Scotland by the friends of the famous writer, includes plenty of alcoholic consumption and readings of his works, which will usually include "Ode to a Haggis."

## Oh Fudge: The Modern-Day Confectioners

Cape May may not be the home of saltwater taffy, but when it comes to fudge, that's another story. At the Washington Street Mall, regardless of the time of year, there is always one person offering fudge samples while standing outside the Original Fudge Kitchen. At the Fudge Kitchen, they still make their fudge the old-fashioned way, whipping the cream in copper kettles.

The fudge is produced by the brothers Bogle, Joe and Paul. Joe had started his candy-making career when he was just twelve years old. They opened his first Fudge Kitchen store in 1972 in Wildwood. A few years later, they opened their first Cape May location. And in 1982, their Washington Street location opened up.

The recipe for making their fudge has not changed in the forty-plus years they have been in business. And as far as those free samples they give out every day, Joe Bogle estimated in 2010 that from the six locations they have in Cape May County, they have handed out twenty-seven thousand pounds of fudge![5]

## West Cape May: The Hipster Granola Sister

While Cape May represents, for most, sea and sophistication, West Cape May has become known for its farms and artisan fare. This community has stepped out of Cape May's shadow and has made a name for itself in recent years. West Cape May is home to the area's only community farmers'

market, as well as annual festivals for strawberries, tomatoes and lima beans. The restaurants have a relaxed, easygoing feel to them that captures the idea of Cape May's hipster granola sister.

In 2012, a Connecticut woman and an Italian man found their way to Cape May to create a unique eating experience. The people in question are Hilary Keever and Contrano Rosettani, and the restaurant is Good Earth Organic Eatery. Hilary and Contrano met in Italy while they were working together on an organic farm. From there, they made olive oil from trees they had bought and eventually found themselves working at a macrobiotic restaurant near Contrano's hometown. They also got married along the way.

After giving birth to their first child, Hilary was feeling homesick, and they decided to move to the United States. But they did not go to Connecticut; they came to Cape May, where Hilary's mother lived. With a grandmother willing to watch their child, Hilary and Contrano decided to start their own restaurant using the knowledge they had gained from their experiences in Italy.

The cuisine is uniquely theirs: a combination of Italian-inspired vegan and macrobiotic cooking that also includes the use of locally sourced fish. Contrano and Hilary are strong believers in supporting the local farmers and fishermen, which helps to keep the local economy going. Their lima bean hummus (recipe featured earlier) is a perfect example of how they embrace the local ingredients and history and present them in an altogether new way. The mantra by which they live and run their restaurant is simple: healthy soil grows healthy food that feeds healthy people who build healthy communities.[6]

Brooke Dodds is *not* the "Empanada Mama," but don't pass any harsh judgment on those who call her by that nickname. Her snug little eatery, Empanada Mama's, first started as a traveling food stand that appeared at festivals and farmers' markets around the area in 2010. The inspiration for making empanadas came from the travels that her family took during Cape May's off-season. Not being able to find empanadas, as well as a belief that "everyone should have access to these tasty little treats," Brooke took matters into her own hands. She was not new to the food business, having worked in local restaurants.[7]

Similar to Good Earth, Brooke takes the empanada concept and incorporates local ingredients. She makes the empanada swing Jersey-style. Her success led to the opening of her own restaurant in 2014, so now the local folk and summertime visitors can nosh on her tasty little treats every day.

## Recipe: Chicken and Cheese Empanada Filling

*This recipe comes from Booke Dodds of Empanada Mama's in West Cape May. This will make three dozen empanadas.*

*Ingredients*

2 chicken breasts, boneless
2 garlic cloves
½ white onion, small dice
3 stalks of celery, small dice
1 red bell pepper, small dice
1 green bell pepper, small dice
2 plum tomatoes, small dice
1 tablespoon olive oil
1 tablespoon turmeric
1 teaspoon coriander, ground
1 teaspoon cumin
1 teaspoon salt
1 teaspoon pepper
½ cup shredded sharp white cheddar
¼ cup crumbled queso fresco

*Directions*

*Roast the chicken breast with garlic and onion in a 350-degree oven until internal temperature reaches 165 degrees. Dice celery, red and green pepper and plum tomatoes. Sauté vegetables in olive oil until tender. Season with spices, salt and pepper. Shred cooked chicken meat and add to vegetables. Add cheeses and mix to combine. Season to taste. Allow to cool.*

*For home use, purchase commercially available precut empanada discs. Stuff, fold and crimp the edges and then bake at 350 degrees for 15 minutes.*

# Cape May Point

The drive along Sunset Boulevard from Cape May to Sunset Beach is primarily done for three reasons: to go to the Cape May Lighthouse; to see the SS *Atlantus* concrete ship (yes, a ship made from concrete), resting

in pieces; and to collect the famous Cape May diamonds—no, not real diamonds but rather crystal quartz-like pebbles—along the beach. But along the way, there are food treasures to be had as well.

Sunset Boulevard is where people go to find the Bread Lady. Who is the Bread Lady, and where do you find her? If you find yourself driving along Sunset Boulevard on a Saturday from April to November, you will know you have arrived long before you can see the destination. That's when you see the line of parked cars on the side of the road for no apparent reason. But the reason is well known by locals and foodie types alike: the Bread Lady is open for business.

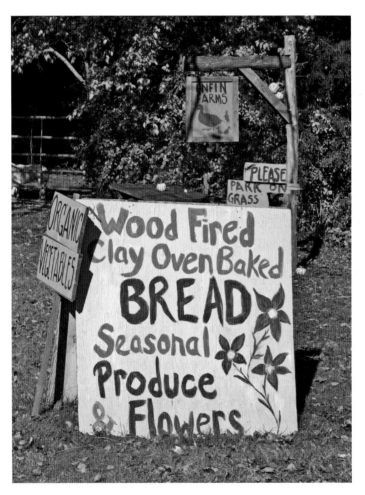

The hand-painted sign in front of the wooden shed where the Bread Lady sells its clay oven–baked breads along Sunset Boulevard.

The Bread Lady is located at Enfin Farm and is actually a partnership of two women. The baker of the artisanal bread is Elizabeth Degener, who uses an outdoor clay oven to produce a variety of breads. Her partner in the venture is Wesley Laudeman, who helps run the business side of things as well as helps out on the farm. The farm itself is owned by the Degener family; the name "Enfin" is Belgian for "finally," and after traveling around the globe for a number of years working on farms, Elizabeth and Wesley finally found their home. The Laudeman name is well known in Cape May, as Wesley's family owns the Lobster House.[8]

The setup for the Bread Lady is beautifully simple. Hand-drawn signs lead customers toward a modest wooden shed where the loaves are resting on display shelves. But don't let the simplicity fool you into thinking that it is a quiet operation. The line in front of the shed forms quickly, and the bread moves out even faster than that.

The community of Cape May Point started as Sea Grove, which was an attempt to build another seaside resort community in the latter half of the nineteenth century. Those plans never came to true fruition, but what Cape

The general store from 1946 is now the Red Store, with a highly regarded restaurant run by a James Beard–nominated chef.

May Point has become is a quiet home for full-time residents. In the center of this planned community is a circle with a pavilion. And on that circle sits the Red Store, which started out as a general store back in 1947. The front of the store still sells sundries, but the back is where Chef Lucas Manteca produces food that has earned him James Beard Award nominations.

Chef Manteca, who comes from Argentina, has always been about sourcing the best of what can be produced locally. Before plying his cooking skills at the Red Store, he had his own restaurant in Stone Harbor and was known to being out early to check to see what the fishing boats had brought in that day. He worked briefly as the executive chef at the Ebbitt Room before finally settling in at the Red Store in 2012 with his wife and business partner, Deanna Ebner. His cuisine is local and seasonal and brings in elements of his own experience from Argentina.

But it doesn't stop there. For a period of time, Lucas and Deanna had their own farm, Fincas del Mar, in West Cape May. They started a small bakery call the Little Store, where pastry chef Michel Gras produces his French breads and rolls. And they have partnered up with Windy Acres Farm in nearby Ocean View to produce honest-to-goodness Jersey sea salt under the name Cape May Sea Salt.

# Food Tourism

The idea of city and regional food tours has become more prevalent in recent years. Getting to know a place by how it eats brings a more personal level of connection. And Mary Ockrymiek is the one who has brought the food tour concept to Cape May. Mary has a background in education, and she has brought that love of sharing a bit of knowledge with her audience to this venture. Having experienced a food tour in another city in the United States, Mary thought that such an idea would work in Cape May. She opened Cape May Food Tours in 2012 and has enjoyed a great amount of success in her endeavor.

Curtis Bashaw sees agritourism as being part of Cape May's DNA. After all, as he pointed out, people have been fishing, farming and visiting here for more than two hundred years. He hopes that the newer generations of business folks continue to build on what already exists. "If we take care of this place," said Bashaw, "it will take care of us for a long time to come."

# End Story: The Rising Tides

Commodore Stephen Decatur was a frequent visitor to Cape Island back in the early 1800s. From 1804 to 1821, Decatur repeatedly measured the distance from Atlantic Hall to the bank at the end of the beach. In 1804, the distance was 334 feet; by 1821, the distance was only 174 feet and 8 inches.

As this book was being completed, Cape May was one of many towns along the Jersey Shore to be met with a harsh winter storm that caused widespread flooding. These types of flooding incidents appear to be happening on a more regular schedule, with the potential damage increasing as well.

This final section is not intended to be a doom-and-gloom prognostication but simply to bring awareness to the fact that nature wins out in the end, despite our best efforts. The original whale village of Town Bank—or, rather, where it was once located—is now sitting at the bottom of Delaware Bay.

Cape May is currently riding a rising tide in popularity. With its combination of beach, Victorian architecture and dining options, not to mention the bed-and-breakfasts and local farms and wineries, there is plenty with which to keep one happily occupied. But like the lost original settlement, things do not last forever. If you plan on coming to Cape May for a visit, come enjoy it in all its splendor sooner rather than later.

Appendix
# A List of Places Mentioned in This Book

*As they say, a good cast deserves to be mentioned twice. The following is a list of restaurants, bars and wineries that have been mentioned in this book and are still open for you to enjoy.*

Angel of the Sea—Bed-and-breakfast. Open all year.
5 Trenton Avenue, Cape May. 609.884.3369. www.angelofthesea.com.

Beach Plum Farm—Farm and farmers' market. Open all year.
140 Stevens Street, West Cape May. 609.884.6542. www.caperesorts.com.

The Blue Pig Tavern—Restaurant serving casual American cuisine. Open all year.
Congress Hall, 200 Congress Place, Cape May. 609.884.8422. www.caperesorts.com.

Cape May Brewing Company—Microbrewery. Open all year.
1288 Hornet Road, Cape May. 609.849.9933. www.capemaybrewery.com.

Cape May Sea Salt Company—Sea salt produced in South Jersey.
www.capemayseasaltco.com.

Cape May Winery & Vineyard—Winery. Open all year.
711 Townbank Road, Cape May. 609.884.1169. www.capemaywinery.com.

# Appendix

THE CHALFONTE—Hotel and restaurant serving southern cuisine. Restaurant open May through October.
301 Howard Street, Cape May. 609.884.8409. www.thechalfonte.com.

C-VIEW INN—Local bar. Open all year.
1380 Washington Street, Cape May. 609.884.4712.

THE EBBITT ROOM AT THE VIRGINIA HOTEL—Hotel and restaurant serving farm-to-fork cuisine. Open all year.
25 Jackson Street, Cape May. 609.884.5700. www.caperesorts.com.

EMPANADA MAMA'S CANTINA—Restaurant serving empanadas. Open all year.
600 Park Boulevard, West Cape May. 609.972.3977. www.empmamas.com.

ENFIN FARM—Clay oven baked breads. Open on weekends from April to November.
609 Sunset Boulevard, Cape May Point.

410 BANK STREET—Restaurant serving French/Creole/Caribbean cuisine. Open May through October.
410 Bank Street, Cape May. 609.884.2127. www.410bankstreet.com.

GODMOTHERS RESTAURANT—Restaurant serving Italian American cuisine. Open March to October.
413 South Broadway, Cape May. 609.884.4543. www.godmothersrestaurant.com.

GOOD EARTH ORGANIC EATERY—Restaurant serving organic, locally sourced cuisine. Open April to October.
600 Park Boulevard, West Cape May. 609.898.6161. www.goodearthorganiceatery.com.

THE LITTLE STORE MARKET—French bakery. Open all year.
1208 Route 109, Cape May. 609.305.4582. www.littlestorecapemay.com.

THE LOBSTER HOUSE—Restaurant and seafood store. Open all year.
Fisherman's Wharf, 905 Schellengers Landing Road, Cape May. 609.884.8293. www.thelobsterhouse.com.

# Appendix

Louisa's Café—Restaurant featuring farm-to-fork cuisine. Open all year.
104 Jackson Street, Cape May. 609.884.5882. www.louisascapemay.com.

The Mad Batter—Restaurant serving casual American cuisine. Open all year.
19 Jackson Street, Cape May. 609.884.5970. www.madbatter.com.

Mainstay Inn—Bed-and-breakfast. Open March to December.
635 Columbia Avenue, Cape May. 609.884.8690. www.mainstayinn.com.

The Merion Inn—Restaurant serving steaks and regional seafood. Open March to October.
106 Decatur Street, Cape May. 609.884.8363. www.merioninn.com.

No-Frills Farm—Farmers' market. Open May to October.
1028 Seashore Road, Cape May.

The Original Fudge Kitchen—Confectionery. Open all year.
513 Washington Street, Cape May.

Rea's Farm—Farm and farmers' market. Open April to October.
Fourth Avenue and Bayshore Road, West Cape May. 609.884.4522.

The Red Store—Restaurant serving South American–inspired farm-to-fork cuisine. Open all year.
500 Cape Avenue, Cape May Point. 609.884.5757. www. capemaypointredstore.com.

Slack Tide Brewing—Microbrewery. Open all year.
1072 Route 83 Unit 3, Clermont. www.slacktidebrewingco.com.

The Ugly Mug—Restaurant and bar serving casual cuisine. Open all year.
426 Washington Street, Cape May. 609.884.3459. www.uglymug.bar.

The Washington Inn—Restaurant serving upscale cuisine. Open all year.
801 Washington Street. Cape May. 609.884.5697. www.washingtoninn.com.

# NOTES

## CHAPTER 1

1. Kraft, *Lenape-Delaware Indian Heritage*, 58.
2. Ibid., 4.
3. Dorwart, *Cape May County, New Jersey*, 7.
4. Kraft, *Lenape-Delaware Indian Heritage*, 283–84.
5. Ibid., 287.
6. Ibid., 286.
7. Heston, *South Jersey*, 517.
8. Scull, "Biographical Notice of Doctor Daniel Coxe," 327.
9. Dorwart, *Cape May County, New Jersey*, 14–15.
10. Marfy Goodspeed, "1688, Daniel Coxe's Schemes," Goodspeed Histories, July 31, 2010, www.goodspeedhistories.com.
11. Pomfret, *Province of West New Jersey*, 174.
12. Berkey, *Early Architecture of Cape May County*, 2.
13. *New-York Weekly Journal*, August 23, 1736, GeneaologyBank.com.
14. Stevens, "Diaries of Aaron Leaming," 69.
15. Dorwart, *Cape May County, New Jersey*, 39.
16. Levitt, *For Want of Trade*, 135–36.
17. Van Hoesen, *Early Taverns and Stagecoach Days in New Jersey*, 95.
18. Mitnick, *New Jersey in the American Revolution*, 27.
19. Recording from the Court of General Quarter Sessions of the Peace in Cape May County, May 28, 1801, Cape May County Clerk's Office, Cape May Court House, New Jersey.

20. Advertisement, *Pennsylvania Gazette*, June 26, 1766, from Alexander, *Ho! For Cape Island!*, 10.
21. "Sea Shore Entertainment" advertisement, *Philadelphia Gazette*, July 2, 1801, from Alexander, *Ho! For Cape Island!*, 14–15.

## CHAPTER 2

1. Berkey, *Early Architecture of Cape May County*, 219.
2. Alexander, *Ho! For Cape Island!*, 13.
3. Ibid., 25.
4. Recording from the Court of General Quarter Sessions of the Peace in Cape May County, May 1825, Cape May County Clerk's Office, Cape May Court House, New Jersey.
5. Smith, *Oxford Companion to American Food and Drink*, 282.
6. Mark Turdo, "Part I—Drinking in Colonial America: One Minister's Drink List," Pommel Cyder, April 15, 2015, www.pommelcyder.wordpress.com.
7. Alexander, *Ho! For Cape Island!*, 52.
8. *Philadelphia Inquirer*, "Cape May," August 1, 1833, GenealogyBank.com.
9. "Sea Bathing. Atlantic Hotel, Cape Island, New-Jersey" advertisement, *Newark Daily Advertiser*, July 7, 1837, GeneaologyBank.com.
10. "Journal by Medrum," "A Visit—1846," from Alexander, *Ho! For Cape Island!*, 91–101.
11. Alexander, *Ho! For Cape Island!*, 83.
12. Ibid., 59.
13. *Trenton State Gazette*, "Henry Clay at Cape May," August 21, 1847, GenealogyBank.com.
14. Alexander, *Ho! For Cape Island!*, 114.
15. Buchholz, *Shore Chronicles*, 68.
16. Alexander, *Ho! For Cape Island!*, 83.
17. Leslie, *Directions for Cookery*, 31.
18. Clinton, *Harriet Tubman*, 86.
19. Buchholz, *Shore Chronicles*, 73.
20. *Baltimore Sun*, August 3 and 12, 1850, GenealogyBank.com.
21. *New York Times*, "A Waiter Stabbed at Cape May," August 6, 1856.
22. *New York Times*, "Homicide at Cape May," July 22, 1865; *Cape May Ocean Wave*, "The Homicide on Sunday," July 19, 1865.
23. Alexander, *Ho! For Cape Island!*, 86.
24. *Cape May Ocean Wave*, August 15, 1872.

25. Advertisement for Mount Vernon Hotel, *Illustrated London Times*, 1853, from Alexander, *Ho! For Cape Island!*, 122–23.

## Chapter 3

1. Jan Whitaker, "America's finest restaurant," Restaurant-ing through history, July 23, 2008, www.restaurant-ingthroughhistory.com.
2. *Cape May Ocean Wave*, June 28, 1865.
3. *Cape May Ocean Wave*, June 23, 1864.
4. *Cape May Ocean Wave*, May 21, 1874.
5. *Cape May Wave*, June 7, 1884.
6. *Cape May Ocean Wave*, "What We Eat," August 8, 1872.
7. Karen Fox, "The Halls Presidents Walked," *Cape May NJ* blog, February 1, 2012, www.capemay.com.
8. Ibid.
9. Ibid.
10. Wilson, *Jersey Shore*, 476.
11. Dorwart, *Cape May County, New Jersey*, 108.
12. *Cape May Ocean Wave*, April 5, 1865.
13. *Cape May Ocean Wave*, July 4, 1873.
14. *New York Times*, June 24, 1877.
15. *New York Times*, July 27, 1877.
16. *Cape May Ocean Wave*, July 3, 1862.
17. *Cape May Ocean Wave*, December 22, 1864.
18. *Cape May Ocean Wave*, August 4, 1870.
19. *Cape May Wave*, July 5, 1884.
20. Heston, *South Jersey*.
21. *Cape May Ocean Wave*, June 15, 1870.
22. *Cape May Ocean Wave*, November 24, 1870.
23. Ledger of Edward W. Dale, Cape May County Clerk's Office, Cape May Court House, New Jersey.

## Chapter 4

1. Dorwart, *Cape May County, New Jersey*, 169–70.
2. *Cape May Star and Wave*, April 4, 1908.

3. *Cape May County Gazette*, "Federal Liquor Agents in Surprise Raid at Resorts," May 1, 1931.
4. *Cape May Star and Wave*, "City Grants Licenses to 8 for Beer," June 22, 1933.
5. *Cape May Star and Wave*, "Evades Law By Joining Fishing Crew," May 4, 1933.
6. Heston, *South Jersey*, 525.
7. *Cape May Star and Wave*, May 4, 1921.
8. John Corr, "A Family Sweet on Its Oceanfront Business," *Philadelphia Inquirer*, August 28, 1992.
9. *Cape May Star and Wave*, "Magistrate Discharges First Case Arising from Beer Order," July 20, 1933.
10. Interview with Ben Miller via e-mail, May 2015.
11. Interview with Steven and Lenore Dash and Carrie (Dash) Warwick via e-mail, 2015.
12. Rhoads and Anderson, *McIntire*, 324–25.

# Chapter 5

1. Gayle Ronan, "Carolyn Pitts, 85, Cape May Booster," *Philadelphia Inquirer*, May 28, 2008.
2. Interview with Kay Busch, manager of the Mad Batter restaurant, December 2014.
3. Ellen Albanese, "Wining and Dining, without Intimidation," *Boston Globe*, June 30, 2004.
4. Bill Kent, "Film Refugees Find Their Calling in Cape May Eateries," *Philadelphia Inquirer*, August 24, 1992.
5. Donald Jackson, "Cape May Bed and Breakfast: Victorian Inns Are the Thing," *New York Times*, July 30, 1989.
6. Interview with Theresa and Ron Stanton via e-mail, March 2016.

# Chapter 6

1. *Cape May Ocean Wave*, April 11, 1861.
2. Dorwart, *Cape May County, New Jersey*, 101.
3. *Cape May Ocean Wave*, "Strawberry Festival," June 19, 1867.
4. *Cape May Ocean Wave*, "The County Fair," September 22, 1870.

5. *Cape May Ocean Wave*, "8000 Chickens at Farmstead," July 11, 1914.

6. Ad for Cape May Farmstead, *Cape May Star and Wave*, January 3, 1914.

7. D. Russell Blair and Elizabeth E. Corson, "WWII Farm Work Cards of Cape May County, NJ Filed by Farmers and Youths," Cape May County Board of Agriculture.

8. Eils Lotozo, "Loving the Lowly Lima Despite Disrespectful Jokes, a Festival at West Cape May Is, Happily, Full of Beans," *Philadelphia Inquirer*, October 16, 1988.

9. *Baltimore Sun*, "West Cape May Farmers Cling to Lima Bean Crop," April 13, 1997.

10. Richard Degener, "Sign of the Times," *Press of Atlantic City*, February 10, 1996.

11. Notes and interview with Joe Alvarez, August 2014.

12. Karen Fox, "No Frills Farm," *Cape May NJ* blog, June 6, 2011, www.capemay.com.

13. Interview with Charles Taylor via e-mail, November 2015.

14. Jill P. Capuzzo, "Produce: Patience Pays," *NJ Monthly* magazine (March 12, 2013), www.njmonthly.com.

15. Interview with Curtis Bashaw via e-mail, February 2016.

16. Dorwart, *Cape May County, New Jersey*, 95.

# Chapter 7

1. Wilson, *Jersey Shore*, 162.

2. Berkey, *Early Architecture of Cape May County*, 10.

3. Wilson, *Jersey Shore*, 155.

4. Stevens, "Dairies of Aaron Leaming," 69.

5. Alexander, *Ho! For Cape Island*, 55.

6. *Cape May Ocean Wave*, May 13, 1875.

7. Interview with Brian Harman of Atlantic Cape Fisheries via e-mail, October 2014.

8. Devin Loring, "Spotlight on Rutgers' Oyster Research at Cape May Canal Draws Industry Out of Shell," *Press of Atlantic City*, February 7, 2015.

9. Kevin McKinney, "Scallops Key to Cape May's Status as Coast's No. 2 Fishery," *Ocean City Sentinel*, June 17, 2015.

## CHAPTER 8

1. *Cape May Ocean Wave*, "Cape May Vineyard," October 10, 1861.
2. Westrich, *New Jersey Wine*, 47.
3. Ibid., 47.
4. Ibid., 53.
5. Judith W. Winne, "Today's Vineyards 'a Labor of Love,'" *Courier-Post*, August 6, 2002.
6. Interview with Dr. Bruce Morrison by e-mail, February 2016.
7. Interview with Luca Turdo, February 2016.
8. Karen Fox, "Pour the Wine," *Cape May Magazine* (Fall 2012).

## CHAPTER 9

1. Thomas and Doebley, *Cape May, Queen of the Seaside Resorts*, 113.
2. Fox, *The Chalfonte*, 175.
3. Ibid., 178.
4. Elisa Lala, "Ugly Mug in Cape May Keeps Entertaining All Year Long," *Press of Atlantic City*, June 21, 2012.
5. Ben Leach, "Fudge Has Been a Lifelong Obsession for Joe and Paul Bogle, Owners of Original Fudge Kitchen," *Press of Atlantic City*, September 21, 2010.
6. Interview with Hilary Keever via e-mail, June 2015.
7. Interview with Brooke Dodds via e-mail, November 2014.
8. Jacqueline L. Urgo, "Cape May Bread Maker at Forefront of New Food Movement," *Philadelphia Inquirer*, November 11, 2014.

# BIBLIOGRAPHY

Alexander, Robert Crozer. *Ho! For Cape Island!* Cape May, NJ: self-published, 1956.

Baisden, Cheryl L. *South Jersey Farming.* Charleston, SC: Arcadia Publishing, 2006.

Berkey, Joan. *Early Architecture of Cape May County.* Cape May Court House, NJ: Cape May County Historical and Genealogical Society, 2008.

Boyer, Charles S. *Old Inns and Taverns in West Jersey.* Camden, NJ: Camden County Historical Society, 1962.

Buchholz, Margaret Thomas. *Shore Chronicles: Diaries and Travelers' Tales from the Jersey Shore, 1764–1955.* Harvey Cedars, NJ: Down the Shore Publishing, 1999.

Campbell, Tunis Gulic. *Hotel Keepers, Head Waiters, and Housekeeprs' Guide.* Boston, MA: Coolidge and Wiley, 1848.

Clinton, Catherine. *Harriet Tubman: The Road to Freedom.* New York: Little, Brown and Company, 2004.

Dorwart, Jeffery M. *Cape May County, New Jersey.* New Brunswick, NJ: Rutgers University Press, 1992.

Dowd, Gregory Evans. *The Indians of New Jersey.* Trenton: New Jersey Historical Commission, Department of State, 1992.

Fox, Karen. *The Chalfonte.* Cape May, NJ: Exit Zero Publishing, 2011.

Heston, Alfred M. *South Jersey—A History, 1664–1924.* New York: Lewis Historical Publishing Company, 1924.

Kopp, Jennifer Brownstone. *Legacies of Cape May.* Ocean City, NJ: Sample Media Inc., 2010.

Kraft, Herbert C. *The Lenape-Delaware Indian Heritage: 10,000 B.C. to A.D. 2000.* N.p.: Lenape Books, 2001.

Leslie, Eliza. *Directions for Cookery, in Its Various Branches.* Philadelphia, PA: E.L. Carey & Hart, 1840.

Levitt, James H. *For Want of Trade: Shipping and the New Jersey Ports, 1680–1783.* Newark: New Jersey Historical Society, 1981.

Mariani, John. *America Eats Out: The Illustrated History of Restaurants, Taverns, Coffee Shops, Speakeasies and Other Establishments that Have Fed Us for 350 Years.* New York: William Morrow and Company, 1991.

Miller, Ben. *The First Resort: Fun, Sun, Fire and Water in Cape May, America's Original Seaside Town.* Rio Grande, NJ: Exit Zero Publishing, 2009.

Mitnick, Barbara J. *New Jersey in the American Revoltuon.* New Brunswick, NJ: Rivergate Books, 2005.

Oliver, Sandra L. *Food in Colonial and Federal America.* Westport, CT: Greenwood Press, 2005.

Pocher, Don, and Pat Pocher. *Cape May in Vintage Postcards.* Dover, NH: Arcadia Publishing, 1998.

Pomfret, John E. *The Province of West New Jersey, 1609–1702.* Princeton, NJ: Princeton University Press, 1956.

Quinzio, Jeri. *Of Sugar and Snow: A History of Ice Cream.* Berkeley: University of California Press, 2009.

Rhoads, Gladys Titzck, and Nancy Titzck Anderson. *McIntire: Defender of Faith and Freedom.* N.p.: Xulon Press, 2012.

Scull, G.D. "Biographical Notice of Doctor Daniel Coxe." *Pennsylvania Magazine of History and Biography* 7 (1883): 327.

Sebold, Kimberly R. *From Marsh to Farm: The Landscape Transformation of Coastal New Jersey.* Washington, D.C.: National Park Service, U.S. Department of the Interior, 1992.

Smith, Andrew. *The Oxford Companion to American Food and Drink.* New York: Oxford University Press, 2007.

Spang, Rebecca L. *The Invention of the Restaurant: Paris and Modern Gastronomic Culture.* Cambridge, MA: Harvard University Press, 2000.

Stevens, Lewis T. "Diaries of Aaron Leaming." *Cape May County Magazine of History and Genealogy* 1, no. 2 (1932): 69.

Thomas, George E., and Carl Doebley. *Cape May, Queen of the Seaside Resorts.* Philadelphia, PA: Art Alliance Press, 1976.

Tomlin, Charles. *Cape May Spray.* Philadelphia, PA: Bradley Brothers, 1913.

Van Hoesen, Walter H. *Early Taverns and Stagecoach Days in New Jersey.* Cranbury, NJ: Associated University Press, 1976.

# Bibliography

Westrich, Sal Alexander. *New Jersey Wine: A Remarkable History*. Charleston, SC: The History Press, 2012.

Wilson, Harold F., PhD. *The Jersey Shore*. New York: Lewis Historical Publishing Company, 1953.

Wright, Jack. *Tommy's Folly, Through Fires, Hurricanes, and War: The Story of Congress Hall, Cape May, America's Oldest Seaside Hotel*. Cape May, NJ: Beach Plum Press, 2003.

YPSCE of the Cape May Baptist Church. *Cape May Cook Book*. Cape May, NJ: Star of the Cape Print, 1894.

# Other Resources

Cape May Food Tours. www.capemayfoodtours.com.

Feeding America: The Historic American Cookbook Project. www.digital.lib.msu.edu/projects/cookbooks.

Library of Congress. www.loc.gov.

Mid-Atlantic Center for the Arts & Humanities. www.capemaymac.org.

The Museum of Cape May County. http://www.cmcmuseum.org.

Warren Bobrow. www.cocktailwhisperer.com.

# INDEX

# Index

Congress Hall  25, 38, 40, 43, 48, 58,
   65, 71, 81, 82, 91, 93, 104, 108,
   126, 127, 129
  presidential visits  51, 52, 53
Corson, John S.  56, 58
Coxe, Dr. Daniel  16, 24
C-View Inn  71, 131

## D

Dale, Edward W.  43, 64
  Hotel Dale  43
Delaware Bay  13, 16, 19, 26, 106, 115,
   116, 139

## E

eating saloon  48, 61
Ebbitt Room, the  90, 104, 138
Ellsworth House  56
Empanada Mama's  134
  chicken and cheese empanada recipe
   135
Essen, William  59, 78

## F

fires in Cape May
  1869  58
  1878  58, 90
  Mount Vernon Hotel 1856  45
  original Congress Hall 1818  25
Fish House Restaurant  49
Flynn, William  66, 68
410 Bank Street  89, 90

## G

Garretson, Aaron  61
Gibbs, Joshua  42
Good Earth Organic Eatery  134
  lima bean recipe  99
Gras, Michel  78
Graves, Nelson Z.  96

## H

Harrod, Benjamin  42
Harwood, Lilburn  36
Hawk Haven Winery  122
Henri's  71, 76
Hotel Cape May  66, 73, 82, 91, 96
Hudson, Henry  16, 100
Hughes, Ellis  20, 23, 24, 25
Hughes, Humphrey  18, 24
Hughes, Memucan  20, 24
Hughes, Thomas H.  25, 40
Huguenots  17

## I

ice cream  30, 31, 32, 33, 48, 59, 61,
   77
  beach plum  101
  lima bean  99

## J

Jackson, Augustus  32, 33
Jessie Creek Winery  123
Johnson, Matthias  43

## K

Kechemeches  14, 15, 106
king crabs  111
Knight, Annie  65
Knight, E.C.  65
Kokes  78
Kokes, Carl V.  78

## L

Lafayette Hotel  59
Leaming, Aaron, Jr.  18, 107, 108
Leaming, Thomas  18, 107
Leaming, Thomas, Jr.  21
lima bean  94, 97
  recipe for lima bean hummus  99
  West Cape May Lima Bean Festival
   97, 98, 99

# Index

# INDEX

# ABOUT THE AUTHOR

John Howard-Fusco started eating at an early age and has not stopped since. From his first meal at the Mad Batter on Jackson Street many years ago, John has always had a soft spot for Cape May. In 2008, he and his wife, Lisa, started the food-centric website Eating in South Jersey. Their site developed a following and received mentions from the *New York Times*, *New Jersey Monthly* magazine and nj.com. In addition to his own site, John has written articles for the *Courier-Post*, *Edible Jersey* magazine, WHYY's NewsWorks website and the online food site Jersey Bites. John is also a member of Slow Food South Jersey Shore. This book brings together John's love of food, Cape May and local history. Oh, and John could use a cheesesteak right about now.